The Campus History Series

UNIVERSITY

OF WYOMING

RICK EWIG AND TAMSEN HERT

Dear Aedian,
Congratulations on
graduation and now wishing
you success in your college
career. Be sure to take some
time now and then to "smell
the flowers!" With much love,
Grammy and
Grampee

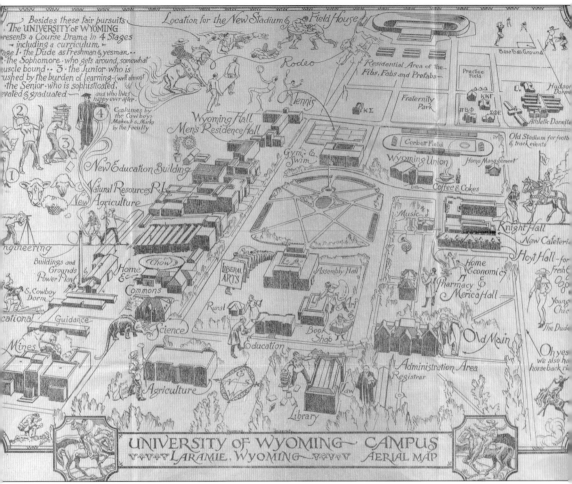

On this aerial map of the University of Wyoming campus from 1949, the text in the upper left corner reads: "Besides these fair pursuits, The University of Wyoming presents a Course Drama in 4 Stages—including a curriculum—Stage 1. the Dude as Freshman & yesman . . . 2. the Sophomore—who gets around, somewhat muscle bound . . . 3. the Junior—who is crushed by the burden of learning—(well almost) . . . 4. the Senior—who is sophisticated, elevated & graduated—and who lives happy ever after." (Courtesy of the Grace Raymond Hebard Map Collection, Emmett D. Chisum Special Collections, University of Wyoming Libraries.)

ON THE COVER: The 1904 University of Wyoming Football Team is pictured here. Members of the team include, in no particular order, John Jones, Bergen Nelson, Clifton Wissler, Joe W. Gillespie, ? Hilton, Dan Nolan, Will Thompson, Herman Langheldt, Herbert Kennedy, M.E. Corthell, Steve Downey, Jean Tidball, William McMurray, Bruce Jones, Captain Yates, Albin Nelson, Charlie Allen, George Peryam, and Leon Kennedy. (Courtesy of the University of Wyoming, American Heritage Center, B.C. Buffum Papers collection.)

The Campus History Series

UNIVERSITY

OF WYOMING

RICK EWIG AND TAMSEN HERT

ARCADIA
PUBLISHING

Published by Arcadia Publishing
Charleston, South Carolina

Printed in the United States of America

Library of Congress Catalog Card Number: 2012939597

For all general information, please contact Arcadia Publishing:
Telephone 843-853-2070
Fax 843-853-0044
E-mail sales@arcadiapublishing.com
For customer service and orders:
Toll-Free 1-888-313-2665

Visit us on the Internet at www.arcadiapublishing.com

*Dedicated to all who helped preserve the history of
the University of Wyoming.*

CONTENTS

Acknowledgments 6

Introduction 7

1. Free Tuition and Equal Admission 9

2. Dinosaurs to Gold Ores 19

3. Home on the Range 39

4. Prepare for Complete Living 59

5. Roaming the University of Wyoming 77

6. On the Heights 87

7. Your University Stands Steadfast in War and Peace 101

8. Wyoming's University 107

Bibliography 127

ACKNOWLEDGMENTS

The authors wish to thank the following for granting us permission to publish images from their repositories: University of Wyoming American Heritage Center; Emmett D. Chisum Special Collections, University of Wyoming Libraries; UW Photo Services; UW Department of Geology and Geophysics; University of Wyoming Alumni Association; and the Wyoming State Archives. Without their assistance, this work would not have been possible.

Several collections in the American Heritage Center (AHC) were used: Samuel H. Knight, B.C. Buffum, A.C. Jones, Clarice Whittenburg, Ludwig-Svenson Studio, Roland W. Brown, UW Physical Plant, and the Wyoming Infrared Observatory Records, as well as the general photo files. The Grace Raymond Hebard Collection (UWL-GRH) in the UW Libraries supplied maps and material from several university publications. The Herbarium specimen and field book entry appears courtesy of the Rocky Mountain Herbarium digitization project (RMH). The Wyoming State Archives (WSA) pulled both photograph collections and vertical files for our use. We relied on UW Photo Services (UWPS) for many of the more recent images.

A work of this magnitude could not reach fruition without the assistance of several archivists and librarians. We wish to acknowledge the assistance of the following individuals: Suzi Taylor and Cindy Brown—Wyoming State Archives; Andrea Binder, Sam Clevenger, Bryce Hamilton, Burmma Hardy, and Katie Lynn—Emmett D. Chisum Special Collections, University of Wyoming Libraries; Dennis Moser, Cindy Kellogg, Mary Richey, Kendall Hutchinson, and Sarah Rundall—Digital Resources Lab, University of Wyoming Libraries; John Waggener, Keith Reynolds, and Vicki Schuster—American Heritage Center; Marlene Carstens—UW Photo Services; and Brendon Orr—UW Department of Geology and Geophysics.

This project would not have been possible without support from the following individuals: Mark Greene, director, UW American Heritage Center; Maggie M. Farrell, dean, University of Wyoming Libraries; Lori Phillips, associate dean, University of Wyoming Libraries; and Kelly Visnak, scholarly communications librarian, University of Wyoming Libraries. We want to acknowledge our Arcadia editors: Coleen Balent for believing in this project and working with us to make it a reality and Amy Kline for her patience in seeing us through the process.

Finally, we offer our thanks for the support, input, and understanding we received from Kristi Wallin and Ken Hert, who endured our research and editing for many weeks.

INTRODUCTION

Wyoming territorial governor Francis E. Warren signed the bill that created the University of Wyoming (UW) on March 4, 1886. The bill also appropriated $50,000 for the first building on campus, now known as Old Main. According to the legislation, the object of the new school was "to provide an efficient means of imparting to young men and young women, on equal terms, a liberal education and thorough knowledge of the different branches of literature, the arts and sciences, with their varied applications."

The establishment of UW as a land-grant institution was the result of the Morrill Act of 1862. Justin Smith Morrill, a U.S. representative and senator from Vermont, was the principal author of the act, which provided federal support for public higher education. The act reflected a growing need for agricultural and technical education in the country. It allowed for 30,000 acres of public land for each member of Congress to be given to each state to be applied to the teaching of agriculture, the mechanic arts, and military tactics while not excluding literary and scientific studies. When it first passed, the Morrill Act only applied to states, but the US Congress changed the law during the early 1880s to include territories, so although Wyoming was not yet a state in 1886, the territory was able to create a land-grant university. As a result, the 42 students who made up the first class in UW's history began their studies in September 1887.

Two years later, in September 1889, forty-nine male delegates met in Cheyenne to participate in Wyoming's Constitutional Convention. In the constitution, the establishment of the university was "confirmed, and said institution, with its several departments, is hereby declared to be the University of the State of Wyoming." Article 7, section 16 of the constitution states: "The University shall be equally open to students of both sexes, irrespective of race or color; and, in order that the instruction furnished may be as nearly free as possible, any amount in addition to the income from its grants of lands and other sources above mentioned, necessary to its support and maintenance in a condition of full efficiency shall be raised by taxation or otherwise, under provisions of the legislature."

The university has always been the only four-year public institution of higher learning in Wyoming. That being the case, UW has always taken seriously its outreach mission within the state. Only a few years after opening its doors, the school used federal funds authorized by the Hatch Act of 1887 to establish agricultural experiment stations in Laramie and elsewhere in the state. In order to provide the results of the experiment stations to ranchers and farmers, in January 1904 UW's College of Agriculture began publishing a monthly bulletin called *Ranchmen's Reminder*. Soon after, the college started teaching short courses about agricultural issues, which soon traveled around the state. The Smith-Lever Act of 1914 established cooperative extension services connected to land-grant institutions, but UW had already started setting up an extension division in 1912, and the state legislature appropriated $10,000 for extension work in agriculture and home economics in 1913. This service has always supported programs such as 4-H, and every county in the state (as well as the Wind River Reservation) has an extension agent today.

The university's outreach and its research activities across the state have involved more than agriculture. During the 1910s, Grace Raymond Hebard, a professor of political economy and Wyoming historian, set up a system of traveling libraries to go to Wyoming cities, towns, agricultural centers, schools, and ranches. Various UW research stations have also been placed around the state. The university began administering the Jackson Hole Research Station, located in Grand Teton National Park, during the early 1950s. The station is a cooperative

venture with the National Park Service at which faculty, students, and researchers from around the country investigate biological, physical, and social sciences in Western national parks. Today, the field research station is located at AMK Ranch within the park. In the 1970s, UW constructed an infrared telescope west of Laramie to study the infrared energy levels of distant stars; the telescope still operates today.

Another requirement of the Morrill Act was the teaching of military science on campus. UW established a cadet corps, and by 1891 the school established the School of Military Science and Tactics; the same year, UW instituted a requirement for all male students to enroll in military drill. After 1900, a female cadet corps was also created, and it lasted for a number of years. During the world wars, the university supported the war efforts by providing facilities for military training. In 1943, UW hosted more than 1,000 men for US Army training. UW president J. Lewis Morrill stated that the "university shall serve the nation in a most vital role both during the war and afterward." Mandatory military training for incoming male students at UW continued until 1965, when the board of trustees changed the policy.

The University of Wyoming has had many areas of distinction, as well as distinguished faculty, throughout its history. Because of Wyoming's many fossil fields, UW has a rich history in the study of geology and paleontology. The much-noted 1899 Fossil Fields Expedition is an early example of the university's leadership in these areas: 100 scientists from around the country participated in the expedition, electing UW geology professor Wilbur C. Knight as the president of the group. Knight also served as the director of the university's geology museum. Knight's son Samuel H. "Doc" Knight, however, had an even greater impact on the school. During his 60 years at UW, Samuel started the university's summer Science Camp, which brought students from all around the country to the Medicine Bow Mountains west of Laramie, gaining national recognition for the geology department. The university's geology department still hosts the Science Camp today. The University of Wyoming Geological Museum is located in the S.H. Knight Geology Building. In 1999, the UW American Heritage Center named Knight "Wyoming Citizen of the Century" for his educational accomplishments during his distinguished career.

From the beginning, the university has played a role in the development of Wyoming's natural resources. UW's first president, John Wesley Hoyt, served from 1887 to 1890 and envisioned mining as one of the fields of study in the school's curricula. In 1897, professor Wilbur Knight told students that Wyoming is well situated for mining, saying, "Our mining resources should be the making of Wyoming and the university should help this field as well as agriculture." Knight may have been speaking specifically about "ore of all kinds," but his statement holds true because the state's natural resources—oil, natural gas, trona, etc.—have played significant roles in the history of the state, including helping to fund the university. UW has provided many trained engineers and others to work in the natural resource industries and continues to provide leadership in the development of Wyoming's natural resources. The School of Energy Resources, established in 2006, looks to enhance UW's energy-related education, research, and outreach, while the Haub School of Environment and Natural Resources advances the understanding and resolution of complex environmental and natural resource challenges.

Throughout its 125-year history, the university has provided an excellent, reasonably priced education. Not only has it educated thousands of Wyoming students, as well as those from out of state, but the university has been a leader in several areas, including agriculture and natural resource development. As the only four-year public university in Wyoming, the school has served as a "unifier in our state," according to UW historian Phil Roberts. Today, the university still connects to its roots as a land-grant institution. Current UW president Tom Buchanan stated, "The University of Wyoming was established as a land-grant university in 1886 and our mission now is the same as it was then: to provide the highest quality education possible for the people of Wyoming. We're proud of the legacy of the land-grant system and even prouder to be one of the finest land-grant institutions in the nation."

One

FREE TUITION AND
EQUAL ADMISSION

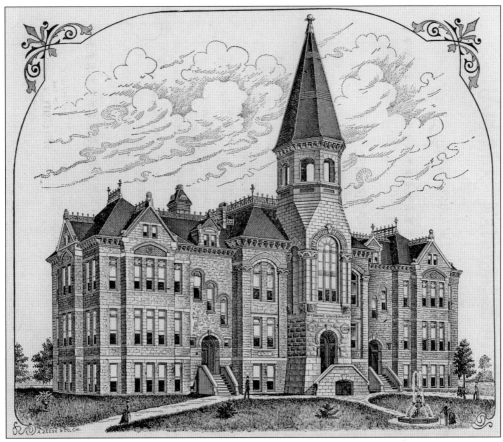

The Ninth Legislative Assembly of the Territory of Wyoming in 1886 provided for a university to be built "in or near the city of Laramie." The goal of the university was "to provide an efficient means of imparting to young men and women, on equal terms, a liberal education and thorough knowledge of the different branches of literature, the arts and sciences, with their varied applications." The intentions of the first UW Board of Trustees, as encapsulated in a May 1, 1886, article in the *Laramie Sentinel*, dictated that education at the new university would be "polytechnic in character, in short that it shall turn out a class of students who, when they graduate shall know how to do something, something the world wants done." This image is from the *First Annual Commencement*, published on June 10, 1891. (UWL-GRH.)

POEM

DELIVERED BY H. V. S. GROESBECK AT THE LAYING OF THE
CORNER STONE OF WYOMING UNIVERSITY.

AH, not for gain or gairish show
 Lay we this broad foundation stone;
Not for ourselves do we bestow
 This largess of our desert zone;
But for the future freemen, great,
Who mold the welfare of the State.

To save them from the black abyss
 That waits who, struggling, gropes his way
Through dark despair or avarice,
 Without the light of open day—
The power instinctively to gain
The dizzy heights with slightest pain.

For them shall Earth her secrets yield,
 The heavens shall more resplendent shine,
The ambient air, the emerald field,
 Shall be for them a treasure mine—
A richer Golden Fleece be wrought
Than ever gladdened Argonaut.

We plant these "academic trees"
 In sterner soil, yet nothing loth,
For sunnier skies and sharper breeze
 Shall stimulate a hardier growth.
Beneath the eternal mountain snows
The fairest flower most surely grows.

O, fair young Commonwealth of ours,
 The great Republic's smallest child,
These massive walls and mighty towers
 By Art from Nature rude beguiled,
This brain-home of our children free,
We dedicate them all to thee.

Grand Master of the Universe,
 Who shaped the mountains and the sea,
Move from this spot thy primal curse,
 Bequeath Thy Light and Liberty,
As handmaids of our future State,
To guard the portals of this gate.

Many gathered for the laying of the first building's cornerstone on September 27, 1886, a bright and windy day in Laramie. A procession of bands, fraternal orders, and hundreds of schoolchildren wound its way through the city's streets to the building. Rev. George H. Cornell, rector of St. Matthews Episcopal Church, addressed the assembled crowd, saying: "We see this edifice the center of a magnificent group of buildings, known as the University of Wyoming, with its rich endowments, its chairs of philosophy, of science and of literature occupied by wise men, and sending forth from its classic halls young men and women educated and well-equipped for the higher duties of life." A cold wind came up, which did not allow for the completion of the dedication ceremony. This poem by H.V.S. Groesbeck, along with other items, was placed in the cornerstone. (WSA.)

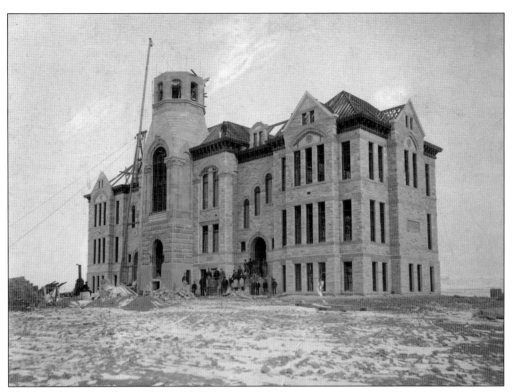

The legislative act that authorized the university provided $50,000 for the construction of the first building, the Hall of Languages (now known as Old Main). This image of the construction of the Hall of Languages, looking northeast towards the building, was taken by S.M. Hartwell & Son Studio of Laramie. The photograph was probably taken in December 1886 before the tower was completed. The tower sat atop Old Main for less than 30 years; because of structural issues, the UW Board of Trustees decided to remove the tower, contracting with Archie Allison of Cheyenne, who removed it in May 1915. (AHC Photo Collections.)

UW Board of Trustees president J.H. Finfrock sent out invitations to attend the dedication and inauguration of the University of Wyoming, held on September 1, 1887. The construction had been completed and the furniture hurriedly installed by the W.H. Holliday Company in time for what was called "University Day." (UWL-GRH.)

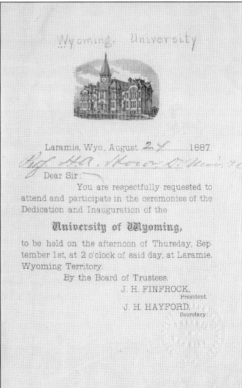

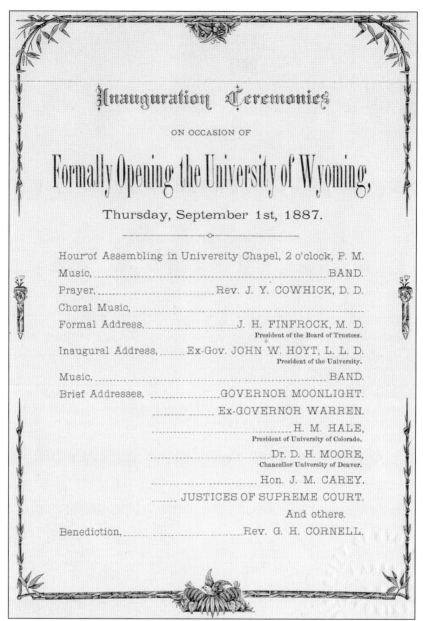

Inauguration Ceremonies

ON OCCASION OF

Formally Opening the University of Wyoming,

Thursday, September 1st, 1887.

Hour of Assembling in University Chapel, 2 o'clock, P. M.

Music, .. BAND.

Prayer, Rev. J. Y. COWHICK, D. D.

Choral Music, ..

Formal Address, J. H. FINFROCK, M. D.
President of the Board of Trustees.

Inaugural Address, Ex-Gov. JOHN W. HOYT, L. L. D.
President of the University.

Music, .. BAND.

Brief Addresses, GOVERNOR MOONLIGHT.

.................... Ex-GOVERNOR WARREN.

... H. M. HALE,
President of University of Colorado.

................................. Dr. D. H. MOORE,
Chancellor University of Denver.

............................. Hon. J. M. CAREY.

...... JUSTICES OF SUPREME COURT.

And others.

Benediction, Rev. G. H. CORNELL.

The University of Wyoming formally opened with the inauguration ceremonies on September 1, 1887. The event, which the *Laramie Boomerang* reported was one of the "most interesting events ever in Laramie," began with music provided by the Laramie Silver Cornet Band. Board of trustees president J.H. Finfrock presented the inaugural address, during which he formally turned over management of the school to Pres. John W. Hoyt. Also attending were former Wyoming governor Francis E. Warren, H.M. Hale (president of the University of Colorado), and D.H. Moore (chancellor of Denver University). The event was held in the "assembly room" in the south end of the newly constructed building. There was an overflow crowd, with many standing in the main lobby. An evening event was held in the same location. The highlight of the evening was the address by Dr. J.H. Hayford, the secretary of the board of trustees. (UWL-GRH.)

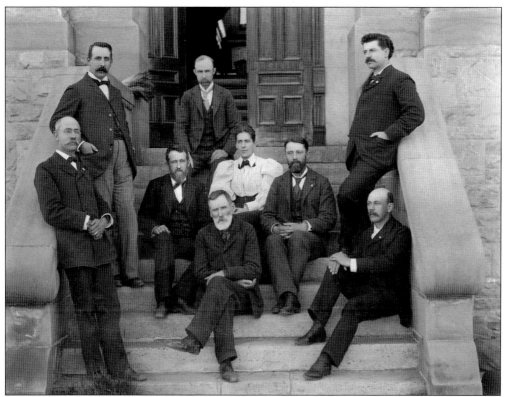

Pictured here are the members of the 1896 UW Board of Trustees. They are, from left to right, (first row) Otto Gramm (standing), James A. McAvoy, and Charles H. Parmelee; (second row, seated) Stephen W. Downey, Grace Raymond Hebard, and Albinius Johnson; (third row, standing) John C. Davis, John O. Churchill, and Timothy F. Burke. (AHC Photo Collections.)

Grace Raymond Hebard served in a number of capacities during the formative years of UW. She arrived in Wyoming in 1882, accepting a position in the US Surveyor's Office in Cheyenne. In 1891, acting governor Amos Barber appointed her to the UW Board of Trustees, a position she held until 1903. During this time, she also served as the board's secretary. From 1908 to 1919, she served as the university librarian, and she was head of the political economy department from 1908 until her retirement in 1931. She actively researched Wyoming history and wrote several articles and books about Wyoming suffrage and Chief Washakie, among other topics. She was also active in marking, preserving, and commemorating historical sites and places along the Oregon Trail. Her papers, held by the American Heritage Center, contain many materials related to the early pioneers of Wyoming. (AHC Photo Collections.)

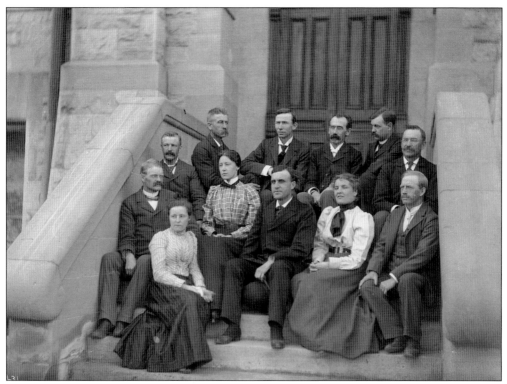

UW faculty member B.C. Buffum took these two photographs. The image above was taken in June 1899 and is of the faculty. The photograph below was taken in April 1898 and features the senior class of the College of Liberal Arts. Buffum was a busy faculty member. He taught all six of the courses in agriculture, as well as classes in veterinary medicine, entomology, and horticulture. (Both, B.C. Buffum Papers, AHC.)

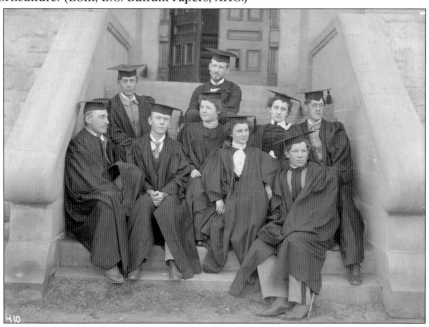

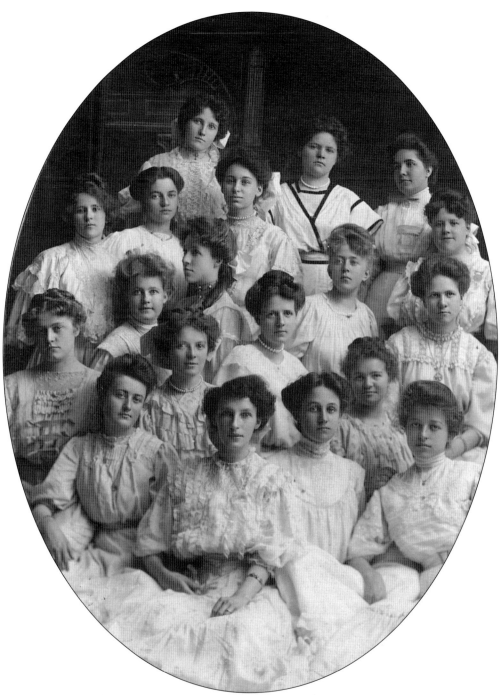

Students from the Pi Beta Phi sorority posed for this photograph in the early 20th century. Pi Beta Phi, founded in 1867 at Monmouth College in Illinois, is recognized as the first national fraternity for women. First called I.C. Sorosis, it changed its name to Pi Beta Phi in 1888. UW's chapter was established in 1910. Other Greek organizations were later established on campus, and by the 1930s the university had six sororities and six fraternities. (A.C. Jones Papers, AHC.)

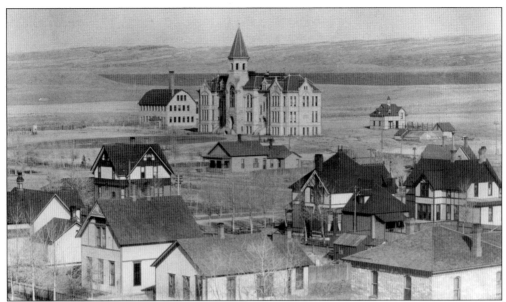

Old Main and the Mechanic Arts Building are seen in this c. 1900 photograph. When Old Main was dedicated in 1887, the *Cheyenne Daily Leader* described it as a "magnificent building, a model institution, a credit to Wyoming, and an ornament to Laramie." The *Laramie Weekly Boomerang* provided a thorough description of the university building on August 18, 1887, stating: "This rare structure, engrafted in this soil, sterile though it may be, without the fostering care of art, surrounded as it is by the grandeur of the mountains and the vastness of the billowy plains, under our clear sky and in our bracing atmosphere, will be the most grateful and generous benediction and legacy that can be bestowed upon our children and our children's children." Offices, classrooms, laboratories, and the first library were allotted space within the new structure. The same article also noted, "By the generous gift of Judge C. E. Clay, formerly of Rock Creek, but now of Douglas, a valuable collection of books has come to the university as the foundation of a future library." A number of these original books are found today in the Toppan Rare Books Library at the American Heritage Center and in the Emmett D. Chisum Special Collections at the UW Libraries. (Both, AHC Photo Collections.)

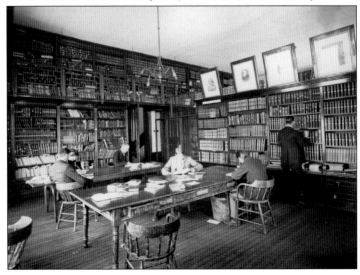

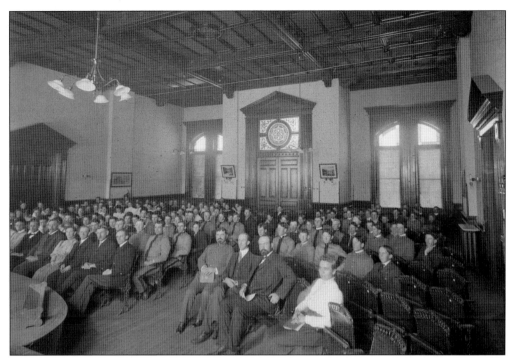

The auditorium in Old Main was an active place in the early history of the university. Faculty and students assembled twice a week in the room for a public meeting. According to the February 1904 *University Bulletin*, the "service is introduced by singing a song from the College Hymnal. Announcements are then made by the different members of the faculty, and the President usually takes advantage of the opportunity to speak upon some subject bearing on the general and moral life of the University. Being a State Institution, any subject that would even suggest a creed or form of belief or a sectarian controversy is carefully avoided." Outside speakers also graced the auditorium. (B.C. Buffum Papers, AHC.)

UW faculty and students formed a number of clubs and organizations in the school's early years. The Camera Club, formed in 1899, is shown in this image. (AHC Photo Collections.)

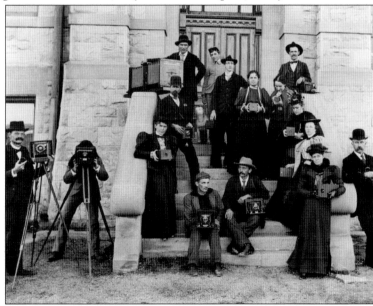

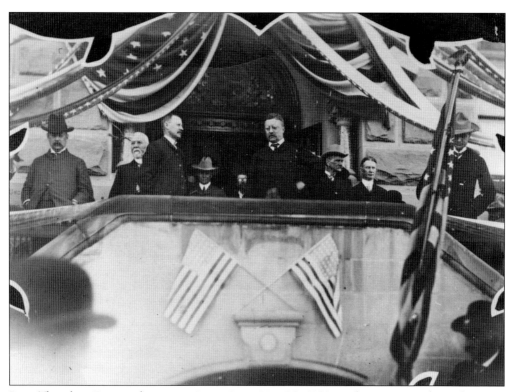

Pres. Theodore Roosevelt came to Laramie on May 30, 1903, and gave a speech on the steps of Old Main. When people in Laramie heard that the president was going to take a trip around the American West during the spring 1903, they sent an invitation for him to visit UW. Roosevelt arrived at 7:30 a.m. that sunny day and was welcomed by Spanish-American War veterans, Sen. Francis E. Warren, and Laramie mayor A.E. Miller. The group then rode to the campus, where the president met UW president E.E. Smiley, the board of trustees, and the faculty. When Roosevelt climbed up the west steps of Old Main, he reviewed a parade of veterans, the university's men's and women's cadet corps, and the Grand Army of the Republic (GAR). In his speech, Roosevelt spoke of building character and courage. Both Roosevelt and Secretary of Agriculture James Wilson spoke of the development of Wyoming agriculture, and Wilson said he would see to it that the UW College of Agriculture would be given anything it needed. After the speech, Roosevelt and several others enjoyed a 10-hour horseback ride to Cheyenne. Other presidents also visited the university. In March 1950, Pres. Harry Truman spoke about the evils of communism, and 13 years later, in September 1963, Pres. John F. Kennedy spoke in the field house. (Both, AHC Photo Collections.)

Two

DINOSAURS TO GOLD ORES

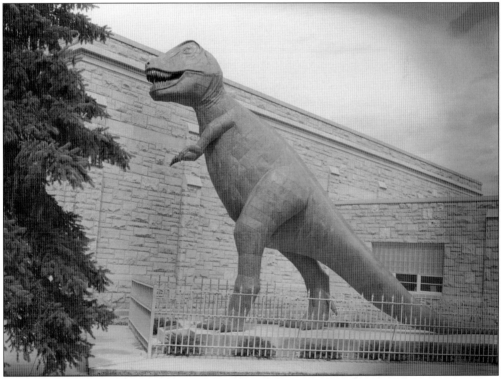

The *Circular of General Information, 1887-1888* announced programs and courses offered at the new institution. It was a broad curriculum covering all aspects of a classical, yet practical, education. Dr. L.D. Ricketts, territorial geologist, was the first lecturer of Applied Geology and Mineralogy. The original School of Mines was charged with providing "a practical as well as theoretical knowledge of mining and metallurgy." Courses offered included general economic geology, assaying of minerals, topographical mapping, mining machinery, and history of mining. Programs in geology, natural resources, and energy resources continue today. This Tyrannosaurus rex statue stands sentinel east of the entrance to the UW Geological Museum. (S.H. Knight Papers, AHC.)

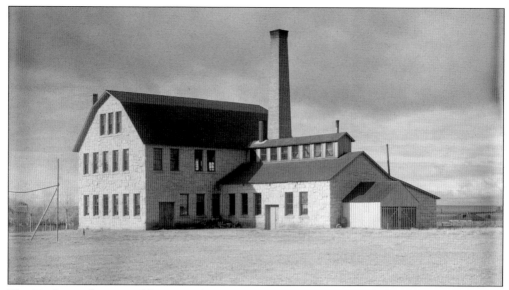

The Mechanical Arts Building was the second building on campus. Designed by Prof. Luke Colburn of the College of Engineering, it was completed in 1893. Constructed of brick with natural stone on the outside, it was ready for use for the fall term. The 65-foot chimney was removed in 1934. A large wing with a gambrel roof was added in 1897 for use by the School of Mines. The building remained standing until after World War II. (B.C. Buffum Papers, AHC.)

The new building was home to the College of Mechanical Arts. The first floor held the boiler room, engine room, a forging and foundry room, and a large room for iron work. The second floor was divided into offices, a recitation room, and a shop for woodworking. This 1897 photograph shows the Mechanic Arts Laboratory. (S.H. Knight Papers, AHC.)

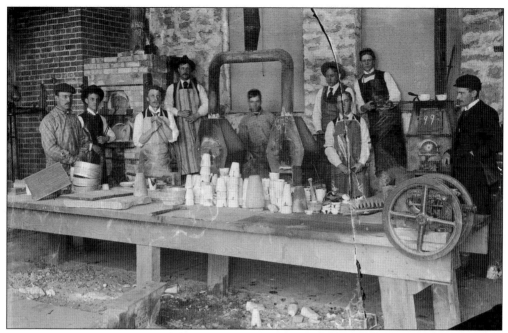

A course in assaying was one of the School of Mines offerings taught by Prof. Wilbur C. Knight. For a number of years, assaying was provided to the citizens of Wyoming for a nominal fee. The *Seventh Annual Catalogue* of the university provides a price list with fees ranging from 50¢ for lead to $5 for platinum and cobalt. Water analysis was also available. (S.H. Knight Papers, AHC.)

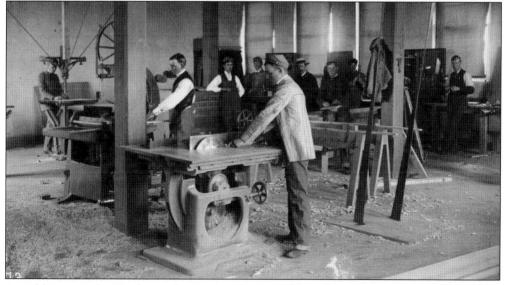

An addition to the Mechanical Arts Building in 1897 provided additional space for the growing curriculum. Professor Knight addressed the assembled students and, according to the *Boomerang*, mentioned that the university is situated so that a course of study in mining engineering, assaying, and metallurgy is very practical, "The hills surrounding us are filled with ore of all kinds to work upon. Our mining resources should be the making of Wyoming and the university should help this field as well as agriculture." (S.H. Knight Papers, AHC.)

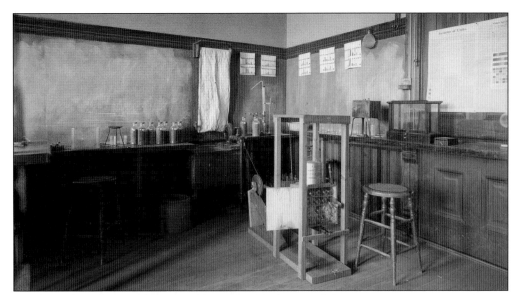

Faculty and students in the UW College of Agriculture and the Wyoming Experiment Station conducted research on a variety of topics using facilities such as the Soil Physics Laboratory pictured here on April 8, 1899. One area of research specified in the 1896–1897 *University Catalogue* was the chemical analysis of soils and water. Results of many studies were published in the station bulletins, which were sent to Wyoming residents for free upon request. (B.C. Buffum Papers, AHC.)

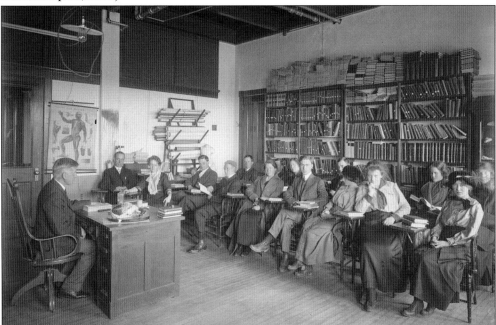

Noted UW professor Aven Nelson is shown here with his 1912 botany class. Courses in botany were elective—except for Botany I and II, which were foundation courses—and could be taken in any order. General botany included both laboratory and fieldwork. Botany III (Plant Histology) included learning the technique of sectioning, staining, and mounting specimens. (S.H. Knight Papers, AHC.)

FOSSIL
DISCOVERIES
IN
WYOMING

In 1899, Union Pacific Railroad invited geologists and paleontologists from universities, colleges, and museums to participate in a scientific expedition to Wyoming, which was famous for being one of the richest fossil regions in the United States. Union Pacific offered free transportation to Laramie for interested parties, who gathered on the campus of the University of Wyoming on July 19, 1899. The group convened in the auditorium of Old Main and elected Prof. Wilbur Knight as president and director of the expedition. Laramie welcomed the scientists with an evening reception, where Col. Stephen W. Downey addressed them. His comments were recorded by the *Daily Boomerang* on July 26, 1899: "It is a cherished design of the management of this university to establish in the near future a permanent school of geology and paleontology. . . . The establishment of a school like that contemplated by the university management would thus not only aid in the diffusion of scientific knowledge and be of social advantage, but would increase by many dollars the revenues of the merchants, hotel and restaurant keepers, liverymen, and all engaged in any business enterprise whatever." Approximately 100 scientists participated in the expedition, which departed Laramie on July 21. This is the cover of *Fossil Discoveries in Wyoming*, issued by Union Pacific, which contains accounts of the experience. (UWL-GRH.)

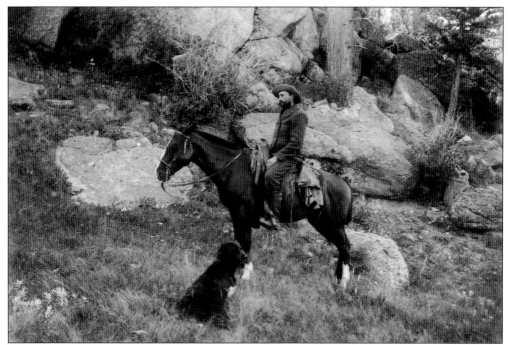

Above, geology professor Wilbur C. Knight is pictured astride his saddle horse during the 1899 Fossil Fields Expedition. Dr. Knight led the foray into the fossil-laden, geologically rich areas of Wyoming. Born in Rochelle, Illinois, he graduated from the University of Nebraska in 1886. During 1886 and 1887, he served as assistant territorial geologist of Wyoming and was appointed state geologist in 1898. He joined the UW faculty in 1893 and, in addition to his instructional responsibilities, was the curator of the Geology Museum. He was elected president of the Fossil Fields Expedition and also served as its director. Those who followed him into the field gave him high marks for his leadership. Feeding such a large group of scientists required a number of cooks, some of whom are pictured below, including Andrew Reed (far left) and Tom Canada (center). The July 26, 1899, *Laramie Boomerang* listed five cooks employed for the trip: Canada, John Christianson, Andrew Reid [sic], Fred Moore, and Sam Enbank. (Both, S.H. Knight Papers, AHC.)

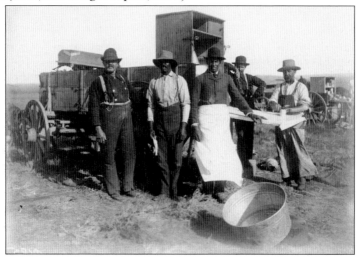

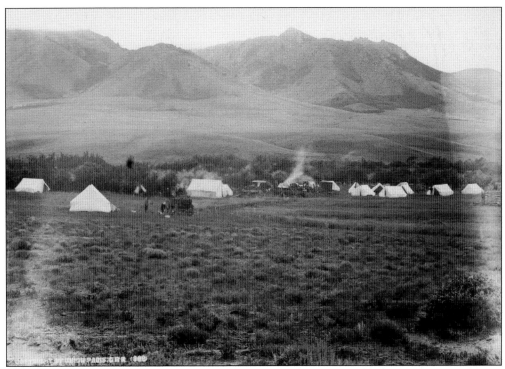

The Fossil Fields Expedition departed from Laramie in small groups on Friday, July 21, 1899. The "outfit" included 19 two-horse wagons and some saddle horses. According to Charles Schuchert, who reported on the expedition in the November 17, 1899, issue of *Science,* they traveled nearly 300 miles in 40 days, making 18 camps. One of the longer stays was in the region known as the Freeze-Out Hills, seen in both of these images. (Both, S.H. Knight Papers, AHC.)

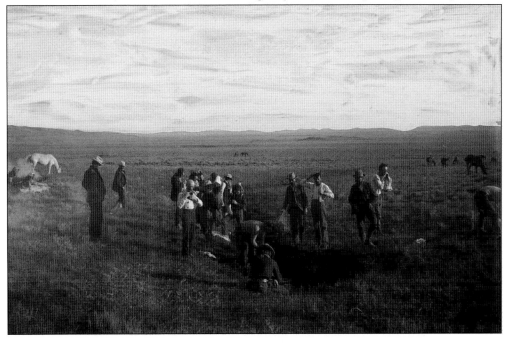

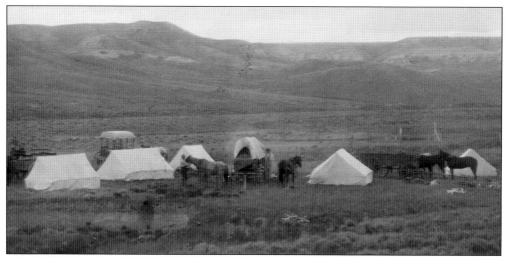

This is another view of the camp in the Freeze-Out Hills. The *Laramie Daily Boomerang* had a reporter traveling with the group, and in his account dated August 3, 1899, he stated, "The expedition could not hope for better success than was met with at this place during the last two days. This is right at the head of the dinosaur country." Tons of fossils unearthed during the course of the group's travels were shipped to their home institutions courtesy of Union Pacific. Following their visit to the Grand Canyon of the Platte, those remaining in the party returned to Laramie near the end of August. (S.H. Knight Papers, AHC.)

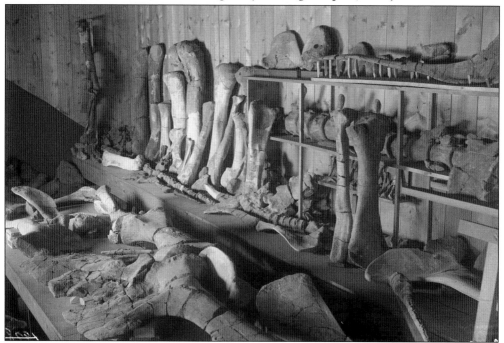

The collection of fossils in the rich Wyoming fields provided a great resource for students studying geology as well as exhibit material for the museum. This is a photograph of the "Bone Room" in the Mechanical Arts Building. The *University Catalogue* noted that fossils sent to the university "will be identified and the formation to which they belong determined free of charge, provided the fossils can remain in our collection." (S.H. Knight Papers, AHC.)

The Science Hall, now known as the Samuel H. Knight Geology Building, was the third building added to the UW campus and is the second-oldest building still standing. In 1899, additional land acquisition brought the campus to 40 acres; this provided space for the Science Hall. Architect Charles Murdock of Omaha, Nebraska, designed the building, which is constructed of native sandstone. Built in the Collegiate Gothic style, it was 50 feet wide by 80 feet long with three stories. The building, completed in 1902, also provided space for the museum in the basement. Additions were made in the 1950s, and the Earth Science Building was connected to the structure in the 1990s. (B. C. Buffum Papers, AHC.)

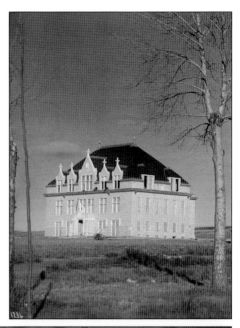

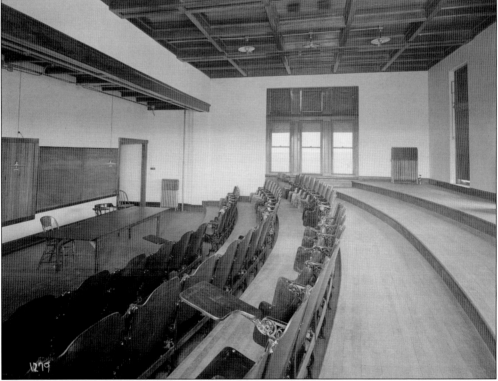

The Main Lecture Hall, shown here in a February 12, 1904, photograph, was located on the second floor of the Science Hall. This room, with seats arranged in an amphitheater style, was designed so that every seat had a good view of the demonstration tables and the experiments performed there. This room, which is still used today, seats over 100. (B.C. Buffum Papers, AHC.)

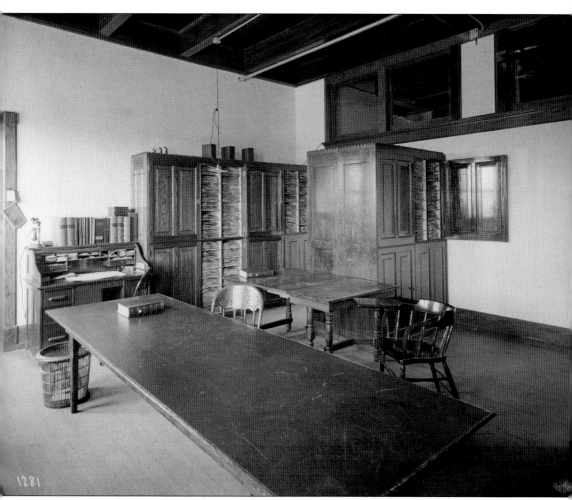

The Rocky Mountain Herbarium, located in the Science Hall, is pictured here on February 12, 1904. Botanist and professor Aven Nelson spent the summer of 1899 on a collecting trip through Wyoming to Yellowstone National Park and the Grand Tetons. The collection of botanical specimens from around the state was growing so rapidly that Dr. Nelson recommended naming it the Rocky Mountain Herbarium. This is now considered the largest collection of Rocky Mountain plants and fungi in existence. Holding 825,000 specimens, and is the largest facility of its kind between St. Louis, Missouri, and Berkeley, California. Many of the specimens are being digitized and can be searched online via the Specimen Database. (B.C. Buffum Papers, AHC.)

Aven Nelson was considered the "preeminent botanist" in the Rocky Mountain region. Traversing Wyoming and other Western regions collecting botanical specimens, he built the Rocky Mountain Herbarium from scratch. Nelson made his first serious collecting trip in the summer of 1894, planned as a systematic survey of Wyoming. Prof. Wilbur C. Knight and others accompanied him. Pictured is *Trifolium dasyphylum*, one of the specimens gathered during the 1894 expedition. (RMH.)

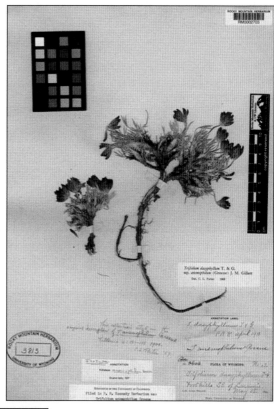

Led by William H. Reed, the 1894 expedition group including Profs. Wilbur C. Knight and Aven Nelson traveled to Douglas, Casper, Lander, Jackson Hole, Green River, South Pass, and Bates Hole. Here is a page taken from the field book noting where Nelson gathered the plants. (RMH.)

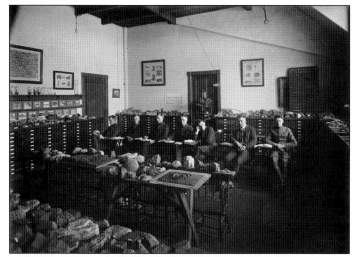

When this photograph was taken in 1918, geology courses were listed as part of the College of Liberal Arts. There is no record of exactly which class this was, but four were listed in the 1917 catalogue: General Geology, Historical Geology, Elementary Paleontology, and Stratigraphical Geology. (S.H. Knight Papers, AHC.)

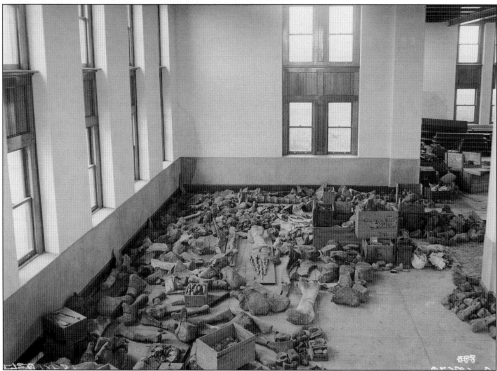

Brent Breithaupt, former curator of the UW Geological Museum, documented the history of the museum in 1986. He noted that in the early years, the fossil specimens were located in the basement of the Mechanical Arts Building as well as in the geology laboratory and in a small bone room. With the construction of the Science Hall, the museum was located in the basement, which had a 16-foot ceiling. This 1902 photograph may document the moving of the fossil collection to the new building. According to Breithaupt, "All of the museum's collections from elsewhere on campus were moved to this building. . . . Unfortunately, some of the fossil specimens were damaged by students moving the collections in bulk. Using wheelbarrows to haul material to the Hall of Science, they simply dumped the precious specimens on the floor." (S.H. Knight Papers, AHC.)

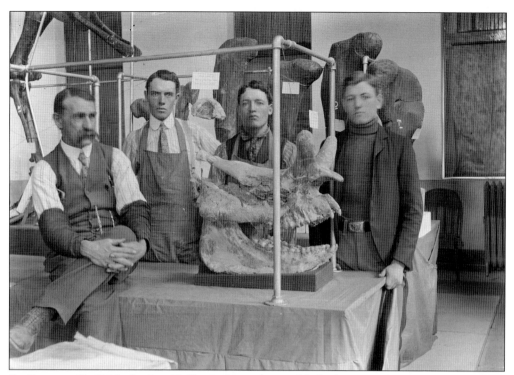

On January 19, 1906, the *Star Valley Independent* published a story about some of the new fossils in the Geological Museum at the University of Wyoming. It stated that William H. Reed, curator of the museum, has "recently mounted the skull of a Titanotherium which was found in Carbon County in 1905. This skull is peculiar in that it had two pairs of horns, one pair on the nose and one on the back of the head." Titanotheres formed a comparatively short-lived family and appear to have been confined almost entirely to North America. Titanothere beds are found in eastern Wyoming, western Nebraska, and the Dakotas. Reed is pictured on the left with the skull and the work crew. (S.H. Knight Papers, AHC.)

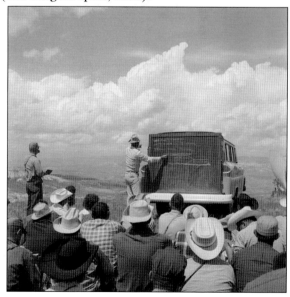

Following in the footsteps of his father, "Doc" Knight led interested students into the field as part of their education. In his biography of S.H. Knight, Frederick Reckling describes Knight's chalkboard lectures, "Students would sit agog as he proceeded to bring to life, with multi-colored three-dimensional chalk drawings, the awesome events and splendid panorama of an ever-changing globe." His artwork brought to life the deposition of sediments, eruption of volcanoes, and erosion of plateaus into deep canyons. Former students fondly recall these lectures. (S.H. Knight Papers, AHC.)

31

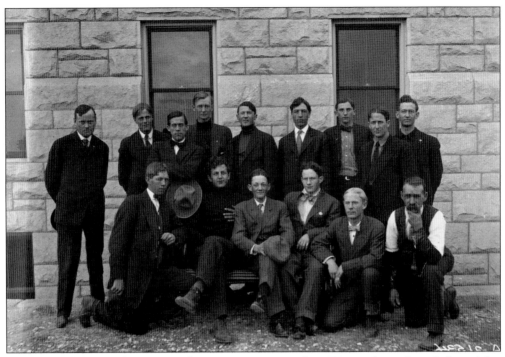

This image from April 13, 1910, shows a UW mining class. Pictured are, from left to right, (sitting) ? Swanson, Marion Nye Wheeler, Isaac Carroll Jefferis, Lester Shaw Worthington, Samuel Clifford Dickenson, and W. H. Reed; (standing) Albert C. Dart, George Howard Mosey, Edward Deane Hunton, Oscar E. Prestegard, Fred Vernon Skinner, John Duncan Carr, S.H. Knight, Donald Chester Foote, and unidentified. (S.H. Knight Papers, AHC.)

This 1910–1911 geology class included, from left to right, Harry Hill, Jean Campbell, Lee Wolford, Ann Nichols, Gilbert Irish, Wilbur Hitchcock, Carl Rai Ford, Jessie Mann, Lena Brooks, B.H. Graves, and William H. Reed. (S.H. Knight Papers, AHC.)

A "delightful way to spend the Fourth of July" was what it was unanimously called by all who participated in the 1919 summer-school picnic held at Centennial, Wyoming. The photograph above shows the group's arrival at the depot of the Colorado, Wyoming & Eastern Railroad in Centennial. This depot is now home to the Nici Self Museum. The photograph below shows University of Wyoming president Aven Nelson leading a group of 125 up the mountain to the "falls." In addition to hiking and fishing, participants were treated to dancing in the pavilion, which was arranged by Centennial residents with music furnished by the five-piece Thompson Orchestra; in between dances, there was a "Wild West" show. (Both, Roland W. Brown Papers, AHC.)

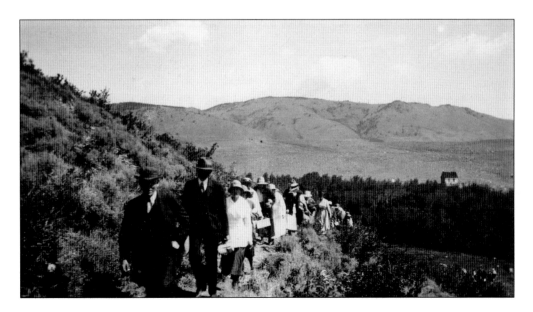

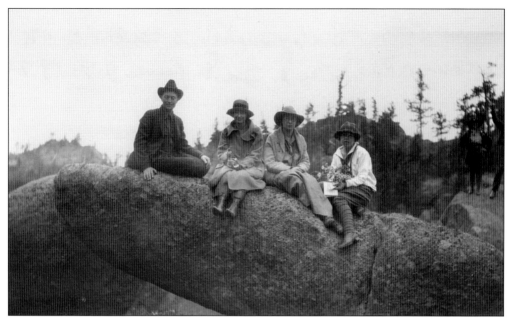

Roland W. Brown took a series of photographs while at summer school at the University of Wyoming in 1920. He attended summer school there from 1919 to 1922. Many of his Kodak images were used in the summer-school brochures published by the university. This image shows UW students on a botany class trip on Saturday, June 28, 1920. (Roland W. Brown Papers, AHC.)

This July 10, 1920, photograph by Roland Brown shows one of two truckloads of University of Wyoming students and teachers ready to visit the Fantastic Wind Erosion Chimney Rock and Animal Trap, located southwest of Laramie. The summer-school session at UW offered lectures, receptions, recitals, and various social gatherings. The most attractive excursions, especially for those who attended from outside the Rocky Mountain region, were the weekend trips to scenic areas near Laramie. (Roland W. Brown Papers, AHC.)

Titled "Four Friends" on the back of the image, these young ladies are enjoying a moment during one of the summer Science Camps. The four students doubled the number of students who attended the first summer Science Camp in 1923. Dr. Knight and Dr. James F. Kemp of the geology department of Columbia University instructed the two students at the camp in Long Canyon, 30 miles northeast of Laramie. That first camp started what would be more than 30 years of cooperation between the geology departments of UW and Columbia. During the 1924 summer camp, which had 25 students enrolled, Dr. Aven Nelson taught a class on botany, and the following year the camp's curriculum included a course on zoology. (S.H. Knight Papers, AHC.)

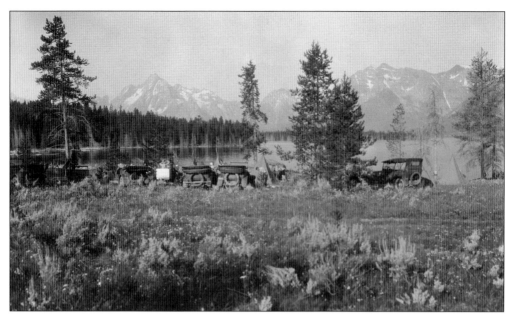

The abundant natural resources of the Laramie area, as well as all of Wyoming, provide great opportunities for fieldwork. In 1899, when Wilbur C. Knight was leading scientists around southeastern Wyoming hunting for fossils, Aven Nelson was exploring the northwestern corner of the state collecting botanical specimens. Others have offered similar experiences for botany, zoology, and geology classes, and during the mid-1980s some Wyoming history classes were even offered "on the road." This is the camp at Jackson Lake, one of the stops on the Yellowstone/Glacier National Park trip in August 1928. (S.H. Knight Papers, AHC.)

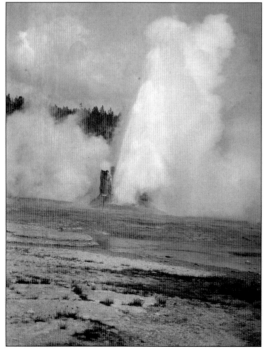

The eruption of Yellowstone National Park's Giant Geyser is a rare occurrence, but students of Samuel H. Knight had the opportunity to see it, as evidenced by this photograph. Although the image is undated, it was likely taken during the 1928 Yellowstone/Glacier National Park trip. Yellowstone was an excellent outdoor laboratory. Following the end of the regular summer field course in geology, class members participated in a three-week trip. The return trip took them over the newly opened Gallatin Highway between Bozeman and West Yellowstone, Montana. (S.H. Knight Papers, AHC.)

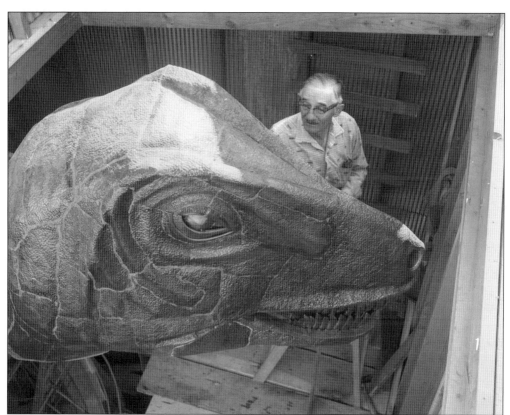

Dr. Samuel Knight, shown above in the box in which he worked to construct the "beast" (the Tyrannosaurus rex that stands outside the UW Geological Museum), estimated that he spent 4,000 hours on the construction of the large carnivorous reptile composed of hand-hammered copper sheets soldered over a 45-foot-long steel frame. According to the *Alumnews*, "On the day of the unveiling the customary Laramie wind was blowing a gale, and the tarpaulin cover had blown off the Tyrannosaurus' head." The fence currently surrounding the T. rex is a remnant of the iron fence that marked the western boundary of the campus between University Avenue and Thornburgh (Ivinson) Street for more than 35 years. (Both, UWPS.)

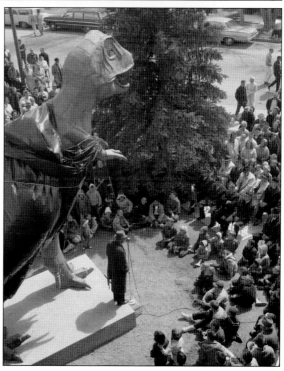

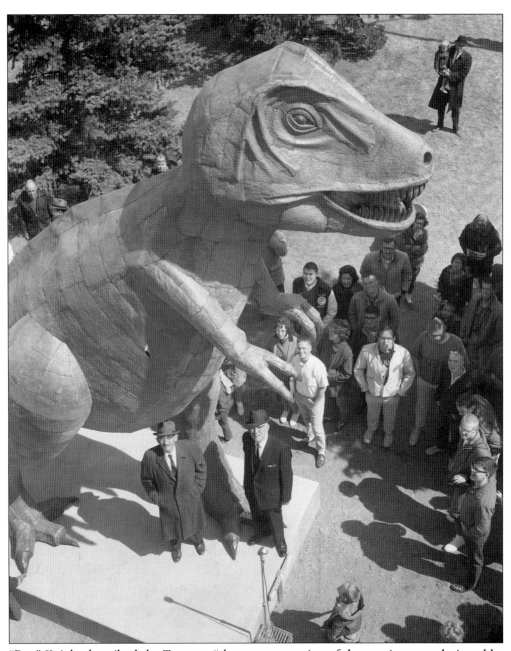

"Doc" Knight described the T. rex as "the greatest engine of destruction ever designed by nature." It is fitting that he created the statue of this creature to keep vigil next to the geology museum. Doc hoped that the copper skin would weather to a characteristic "reptilian green," but the failure of it to tarnish to the type of green found on copper features in more humid climates is likely attributed to the dry Laramie climate. Pictured here are Samuel H. Knight (left) and University of Wyoming president George Duke Humphrey, along with others present at the unveiling of the Knight's Tyrannosaurus rex statue on April 11, 1964. (UWPS.)

Three

HOME ON THE RANGE

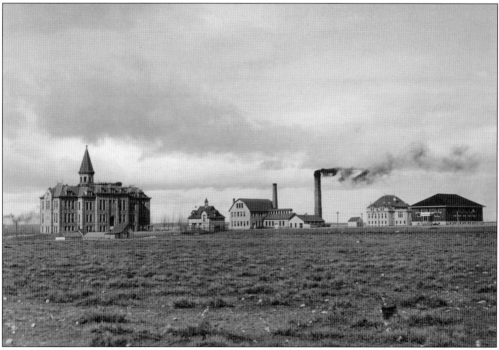

Dated February 15, 1904, this view of the UW campus shows all the buildings of the university at the time. They are, from left to right, the Hall of Languages (Old Main), the barn, the Mechanical Arts Building, the power plant, Science Hall, and the armory/gymnasium. The barn was quite elaborate, and the faculty would leave their buggies and horses there. (S.H. Knight Papers, AHC.)

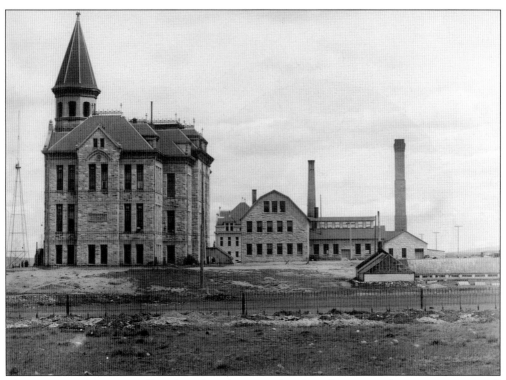

The unique perspective offered in this photograph, taken from Grand Avenue on May 16, 1903, shows the recently completed Science Hall peeking out from behind the Mechanical Arts Building. The greenhouse is also visible, as well as the iron fence that marked the university property. In the 1920s, the fence was moved to the football field south of the gymnasium to enclose future Cowboy gridiron battles. Some pieces of the fence are visible in different areas of the university today. (S.H. Knight Papers, AHC.)

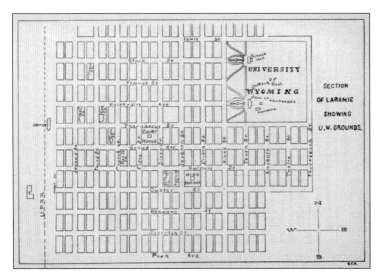

This map, published in the 1899–1900 *University of Wyoming Catalogue*, shows the relationship of the university to the rest of Laramie. For many years, the campus was truly on the outskirts of town, with Green Hill Cemetery being just a little farther north and east. (UWL-GRH.)

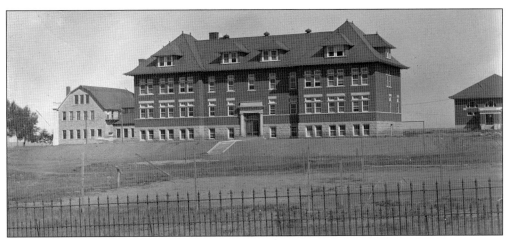

Originally called Women's Hall, the first dormitory constructed on the UW campus was renamed for UW president Charles O. Merica. Since the redbrick of the structure, seen above, did not fit with the natural stone of the other university buildings, it was painted to match. The first part of the building was constructed in 1908 and housed 25 girls, who paid $20 a month for room and board. The domestic science department called this building home until relocating to the new agriculture building in 1951. According to an article in the *Wyoming Alumnus* from January/February 1971, the Nellie Tayloe Ross Room (named in honor of the first female governor in the United States) opened in the basement of the west wing. This room served as the "social center" of the campus until the opening of the Wyoming Union. It ceased functioning as a dormitory by 1943 and has served as office space for a number of departments since. The photograph below, titled "Merica Hall Girls," was taken in 1912. They are wearing "lingerie dresses," a style of the Edwardian era. The outfits could be one or two pieces, usually white, and made of lightweight fabrics such as linen, cotton, or batiste. The redbrick mentioned above is visible in this photograph. (Both, S.H. Knight Papers, AHC.)

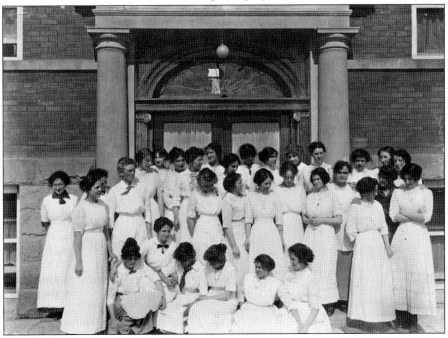

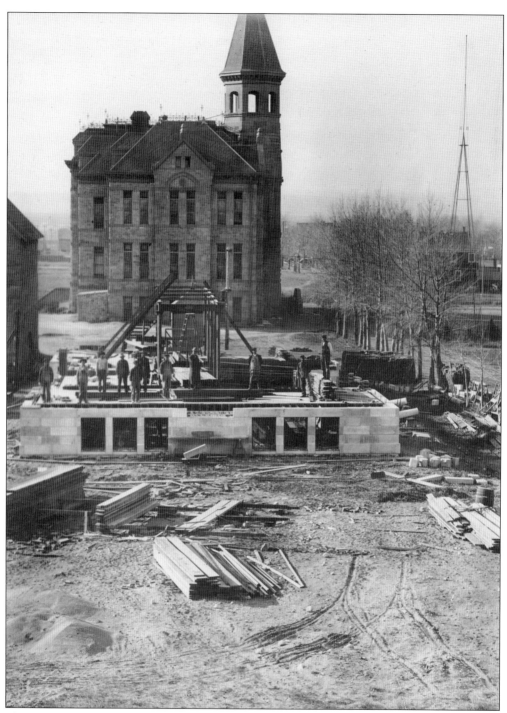

The Normal School opened in 1891. In 1909, the Wyoming Legislature appropriated $50,000 for a building that was completed on August 1, 1910. According to the 1911 *University of Wyoming Catalogue*, it was built of Indiana Bedford stone and "is one of the most beautiful buildings on the campus." Considered to be "modern in every way," the building contained recitation rooms as well as the teachers' training school. (S.H. Knight Papers, AHC.)

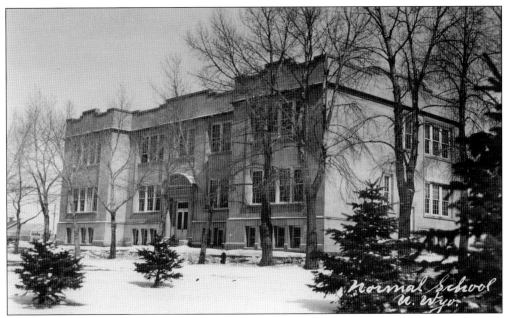

The mission of the Normal School (pictured), as stated in the 1911 *University of Wyoming Catalogue*, was "to prepare teachers for the primary and grammar grades and high schools of the State." Graduates of the program were in high demand in public schools statewide. After the new Education Building was completed, this structure was known as the Graduate School. The building was razed to make space for the new Science Complex. (AHC Photo Collections.)

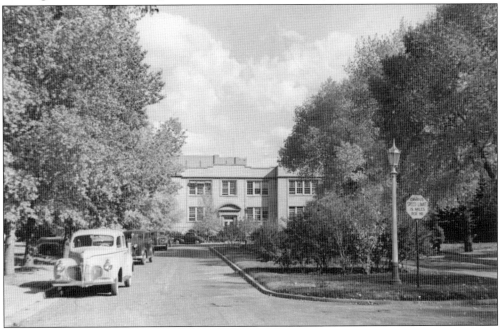

This view of the Normal School shows the main roadway entering the UW campus. Both the building and the entrance, which connected to Fremont Street, were removed when the Science Complex was constructed in the mid-1960s. (Photograph by Arnold Hubbard, AHC Photo Collections.)

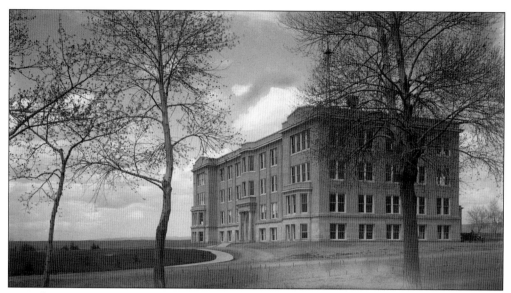

According to an article in the *Wyoming Student*, in 1912 the secretary of the university received instructions to invite five architects to submit plans and specifications for an Agricultural Hall to be erected on campus. The next month, it was announced that William Dubois was chosen as architect. The three-story building was constructed with "impenetrable brick and Bedford sandstone." Upon its opening, it provided quarters for all departments of the Agricultural College and Experiment Station as well as the Department of Chemistry, the state chemist, the Department of Civil and Irrigation Engineering, and the Extension Division in Agriculture and Home Economics. This photograph of the building was taken in 1916. (S.H. Knight Papers, AHC.)

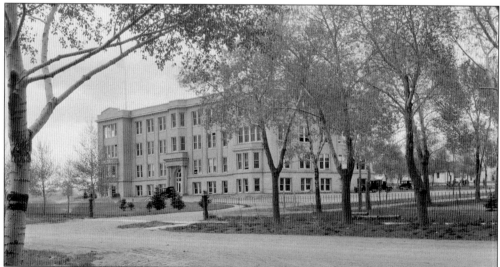

This view, dated 1928 or 1929, shows the Agricultural Hall in winter. A 1950 appraisal and insurance study noted that the construction of this building was high quality and recommended that once the new agriculture building was completed, this one should be used for a combination chemistry and pharmacy building. It was known as the BioChem Building for many years and was recently renovated and expanded for use by the health sciences. (Ludwig-Svenson Studio Collection, AHC.)

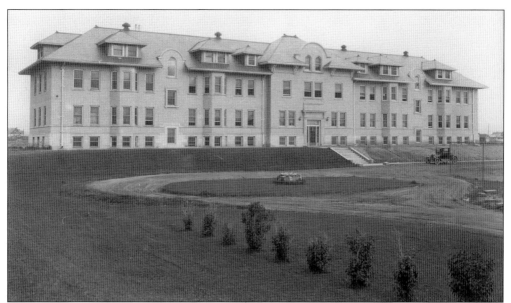

Hoyt Hall was built in 1915 as the second dormitory for women. Designed by architect William Dubois, it was "to be a modern construction, built after the style of many late similar buildings, which are divided into certain sized units." Completed in June and opened in September 1916, the *Wyoming Student* described the interior in a March 17, 1915, article, "The parlor itself, with its fireplace and hardwood finishing, is sufficient to attract even the most bashful boy into those sacred boundaries for a glimpse of the room." It was built with stone from Bedford, Indiana, and gray pressed brick with terra-cotta trimming; the interior trim is of hard oak. The building was named in honor of the first UW president, Dr. John W. Hoyt. After the modern residence halls were built in the 1960s, Hoyt Hall was converted to office space for a number of academic departments, many of which remain there today. The 1918 photograph below includes a few of Hoyt Hall's senior coeds gathered inside. (Above, photograph by J.E. Stimson, WSA; below, Ludwig-Svenson Studio Collection, AHC.)

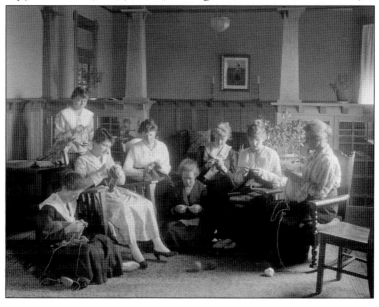

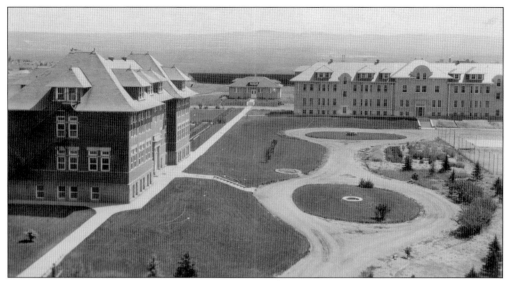

This image shows Merica Hall (left), the Music Building (center), and Hoyt Hall. The Music Building, constructed in 1918, was equipped with four studios, seven practice rooms, and a recital room that was also used as a classroom. Three grand and nine upright pianos were part of the equipment, along with orchestra and band instruments. In 1950, the building was evaluated as part of an insurance appraisal for the university. The report stated that this building occupies a prominent position on the Quadrangle and obstructs the view of Knight Hall. As a frame structure, it did not match the architectural design of other campus buildings and was removed to provide space for Ross Hall. (AHC Photo Collections.)

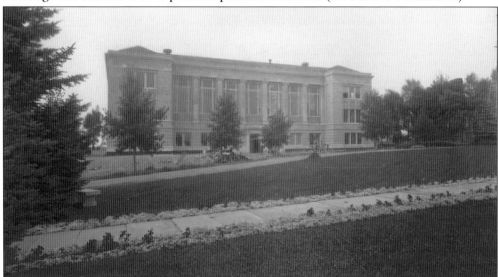

In 1923, the UW Library moved from its home in University Hall (Old Main) into a new library building. According to the *Branding Iron* published on May 14, 1924, "The rapid increase in size of the University library, the need of the Law School for new quarters and the crowded condition existing in the College of Liberal Arts made necessary the erection of a building especially constructed for use in a library." In addition to the library, the new building was home to the English department, Latin and Greek department, the School of Law, and the history department. (Photograph by J.E. Stimson, WSA.)

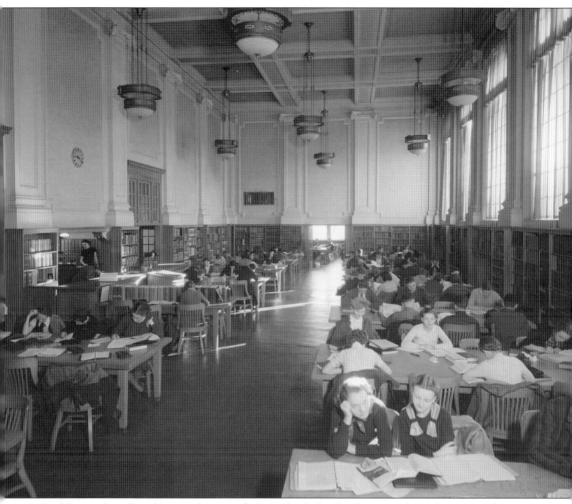

The library handbook issued in 1924 described the facilities and services available on campus. The main floor was divided into a bibliography room, a reading room (pictured), a periodical room, a stack, and offices for library staff. The Hebard Room, named in honor of Grace Raymond Hebard, contained materials related to Wyoming history. Gov. William Ross attended the dedication of the new library and commented that the reading room of the new library is the "most beautiful public room in the state of Wyoming." (Ludwig-Svenson Studio Collection, AHC.)

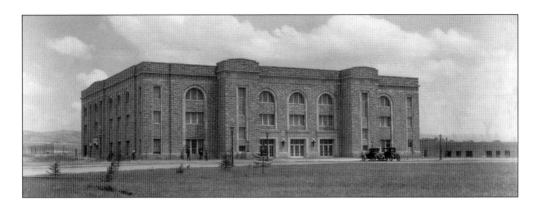

The highly anticipated opening of the new Half Acre Gym (above) in 1924 included a basketball game against the University of Utah Utes, which Wyoming won 31-29. Later in the week, the edifice played host to the junior prom (below). The most notable feature of the new structure is the source of its name: the half-acre gym floor. On October 21, 1924, the *Branding Iron* reported, "Nowhere in the Rocky Mountains can be found a playing floor to equal this one in size covering one-half acre, this floor allows sufficient space for three basketball courts if it is found necessary to put that many into use." The floor, measuring 100 by 180 feet, also serves as an exercise room. The structure also included an armory and a shooting gallery for use by the military department. In October 2011, the *Branding Iron* provided insights into the renovations that will be occurring at Half Acre in the future; according to the architect, the interior will be completely modernized. Construction work is scheduled to begin in 2013. (Both, AHC Photo Collections.)

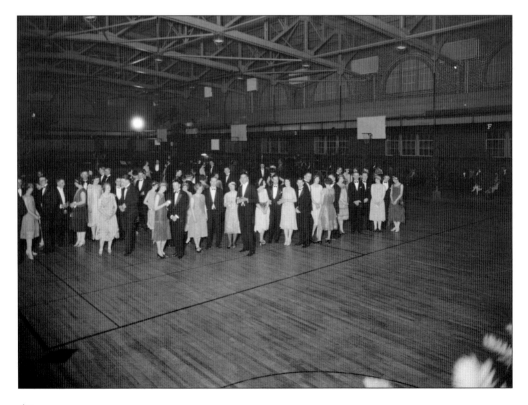

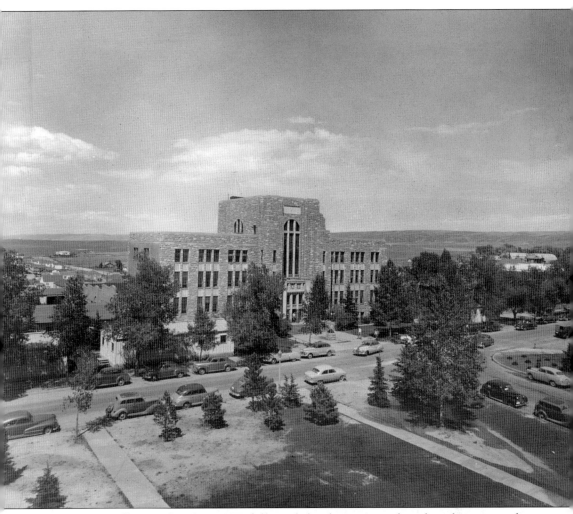

Engineering Hall, completed in 1927, followed the design introduced to the campus by architect Wilbur Hitchcock. As with so many Hitchcock designs, the new building included a tower element. According to an early history of the university, the College of Engineering inherited the old Mechanical Arts Building. In this image, a Butler hut, used after World War II to rapidly increase space, is visible on the left side of the building amidst the trees. (AHC Photo Collections.)

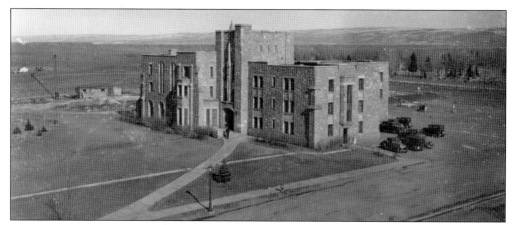

Until 1928, male students attending UW had to find off-campus room and board. The Men's Dormitory, as it was then called, was ready for occupancy in the fall quarter of that year. As reported in the *Branding Iron*, "The large number of men attending here together with the rapid growth of the University has warranted the construction of a men's home." The reporter considered it to be the finest new building on campus. Like many of the early buildings, it was constructed of native stone cut from the university quarry. It was located on what was then the eastern edge of campus. For a time, it was called Graduate Hall, and it was renamed McWhinnie Hall in 1981 in honor of Ralph McWhinnie, the longtime UW registrar. (AHC Photo Collections.)

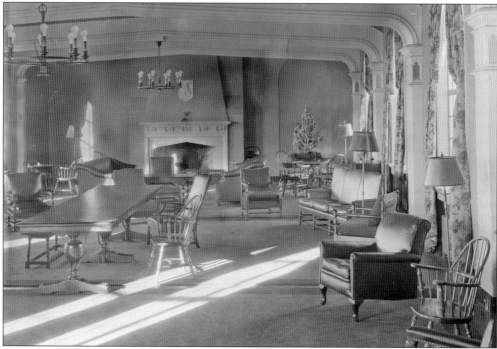

University architect Wilbur Hitchcock was responsible for this splendid structure. The *Branding Iron* described the interior in an August 28, 1928, issue: "At the left of the lobby, one passes into the social hall, a great salon, which is one of the most distinctive features of the entire building. At its far end is a large fireplace embossed with the University Seal and the picture which the class of 1928 purchased for this room." (Ludwig-Svenson Studio Collection, AHC.)

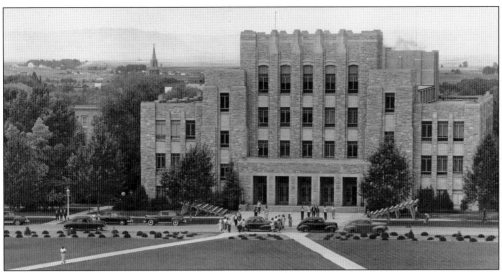

The Liberal Arts Building was described in a 1935 *Branding Iron* article as a "model of modern engineering methods" that "illustrates the present tendency to combine both beauty and utility in architectural designs." The exterior walls are of locally quarried sandstone. According to the article, the stone facing is backed by four inches of hollow clay tile and concrete, making for a fireproof frame. Since it was erected during the Great Depression, funding from the Works Progress Administration (WPA) made the construction of the Liberal Arts Building possible. When it opened in 1936, the auditorium was described as being large enough to house several Little Theaters—the building razed to make room for the new structure. (AHC Photo Collections.)

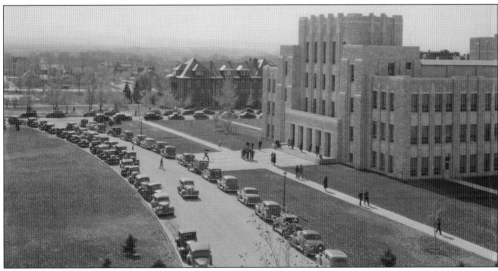

In October 1936, the University of Wyoming hosted two education-related conventions. The Wyoming Education Association (pictured) met October 15–17 with teachers and other school officials from across the state in attendance. One of the prominent educators who addressed the group was UW alumnus Paul L. Essert, the principal of the Emily Griffith Opportunity School in Denver. Registration for the International Relations Clubs of nine Rocky Mountain colleges was held in the new Liberal Arts Building the following week. Eleven colleges were represented, including the University of Utah, Brigham Young University, Colorado College, University of Denver, and Loretto Heights College. (Ludwig-Svenson Studio Collection, AHC.)

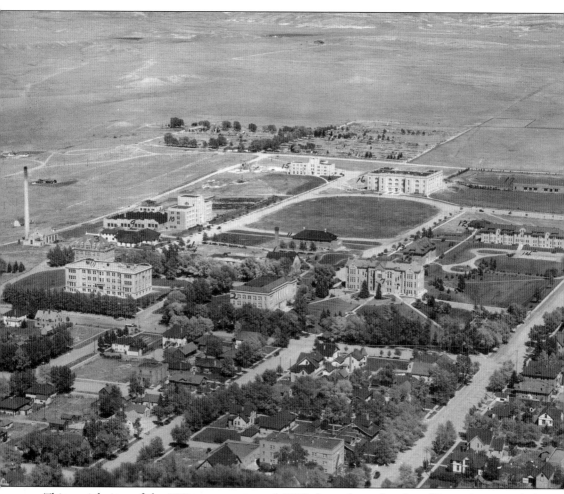

This aerial view of the UW campus around 1930 shows how the city of Laramie expanded eastward meeting the university property at Ninth Street. Facilities and fields pictured are, clockwise from the cemetery (center top), the Men's Residence Hall, Half Acre Gym, Corbett Field (right of Half Acre), the Music Hall, Hoyt Hall, Merica Hall, Old Main, Peanut Pond, Prexy's Pasture, Little Gym/Theatre, Mechanic Arts Building (center), the Library, Normal School Building (hiding behind the trees), Agricultural Hall, Science Hall, old Power Plant, the Commons, and Engineering buildings (center left). Note Grays Gable (now the Quadra Dangle) on the prairie east of Green Hill Cemetery (top center). The following decades brought many changes to the physical design of the campus. (WSA.)

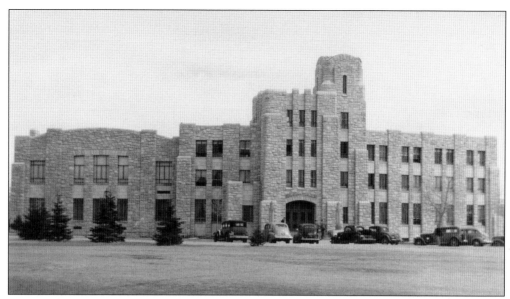

Construction of the Wyoming Union was completed in 1939. It was planned to "serve as a Campus Living Center" for the students and would require students to have membership cards. Faculty could use the facility if they held a guest membership. In the mid-1950s, students called for an addition to the Wyoming Union. The addition would provide student meeting rooms, facilities for recreational activities, and student government offices. The proposal issued by the students even provided for hotel rooms on levels three and four, but the one consulted had "omit" written across those pages. The 1959 expansion included a bookstore, snack bar, bowling alley, and games area, as well as an enlarged ballroom. By the 1970s, with an increased student body, the facility required additional space. (AHC Photo Collections.)

Military uniforms were a common sight on the UW campus during World War II. The university hosted a Civil Aeronautics Authority Pilot Training Course (CPT) at the time. In December 1942, the program was limited to naval aviation cadets. UW provided lodging, meals, and transportation to Brees Field for the cadets. After training 800 cadets, the program ended on May 1, 1944. (AHC Photo Collections.)

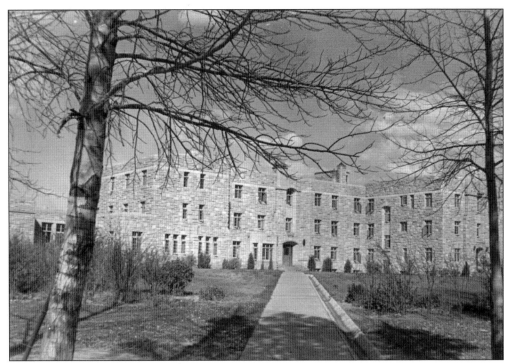

Another women's dormitory, Knight Hall, was named in honor of Emma Howell Knight, the University of Wyoming's first dean of women. Part of a university-oriented family, she was married to Wilbur C. Knight, and her son was well-known professor Samuel H. Knight. The first phase of the dormitory was built in 1941, followed by an addition in 1947. The cafeteria-music annex and the south wing dormitory were completed in 1950. The main dining room could seat more than 575 people at one time, and an additional 200 could be served in the auxiliary dining room. (AHC Photo Collections.)

Knight Hall was the first dormitory equipped with a dining hall where meals were served to all residents. Students residing there were required to pay for room and board for that reason. Shown here is the main hall lounge. Smaller lounges, for females only, were available on each floor. Small kitchens were also available for the residents' use, though they had to supply their own utensils and dishes. A 1941 brochure described the new dormitory and provided a floor plan for each of the three floors. (AHC Photo Collections.)

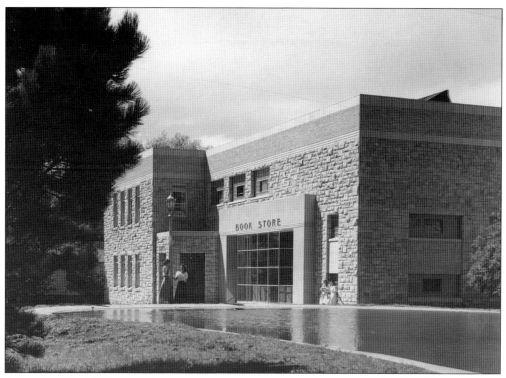

Following World War II, university trustees approved a plan to remodel the old Mechanical Arts Building (see page 56) and use the space to house the campus bookstore and art department. According to a September/October 1966 article in the *Wyoming Alumnews*, "Part way through the project, which included plans for a stone facing, the old building proved too unsound structurally and was razed." The Peanut Pond, located just south of the Mechanical Arts Building that was constructed in 1933 as "an ornament to campus," remained outside the new bookstore (pictured here). The pond was drained in the mid-1950s only to be filled once a year for the freshman-sophomore tug-of-war. (AHC Photo Collections.)

With the old Mechanical Arts Building razed, a new structure was erected following the original foundation lines of the 1893 building. Completed in 1948, it was a combination one- and two-story structure covering just over 14,000 square feet. The campus bookstore relocated to the Wyoming Union in 1960, and a branch of the campus post office was established inside. Both the Peanut Pond and this building were sacrificed for campus improvements. (UWPS.)

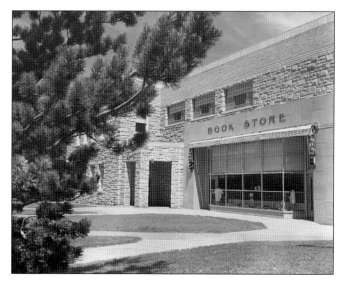

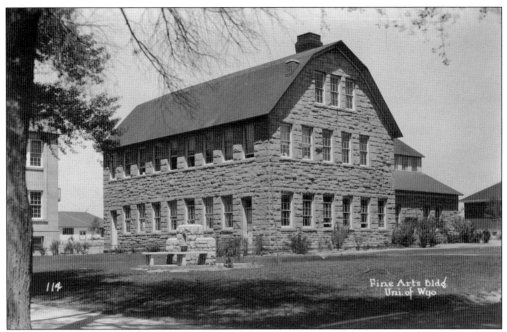

The Mechanical Arts Building stood until the late 1940s. Many departments called it home through the years; this image identifies it as home to the Department of Fine Arts. A growing department, galleries and studios were part of the design for the new structure that was built on the same footprint. Visual arts, music, theatre, and dance operated out of a variety of locations until 1972, when the new Fine Arts Center opened. (AHC Photo Collections.)

Erected as temporary housing in the 1950s, the Hudson Dormitory was located at the corner of 15th Street and Grand Avenue. In July 1948, Pres. Harry Truman signed federal legislation providing $1.45 million for temporary housing on campus. This authorized UW to receive the Hudson Dormitory that provided housing for 376 students, the athletic dormitory north of Talbot Hall, and row houses in what was known as Veteran's Village. Many of these temporary structures were removed long before the 1961 demolition started on the Hudson Dormitory referred to by former students as the "Paper Palace," making way for the new residence halls. (UWPS.)

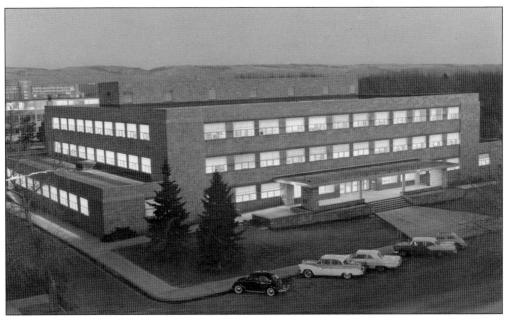

With the growth in the student population after World War II, facilities across campus became inadequate. As early as 1951, discussions began to address the need for a new library structure. In 1958, the William Robertson Coe Library opened next door to the Wyoming Union. Coe bequeathed the funding for a new library and the School of American Studies. (AHC Photo Collections.)

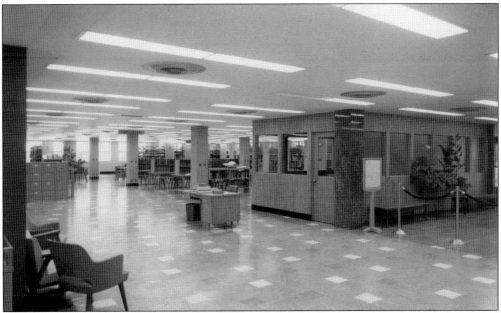

This 1958 photograph shows the general reference and humanities area of Coe Library. The entrance to the library was on the west side of the building on 13th Street. During renovations in 2009, this area was converted to book stacks, and the porch was enclosed to become the Alma Doke McMurry Reading Room, which opened on November 17, 2011. (AHC Photo Collections.)

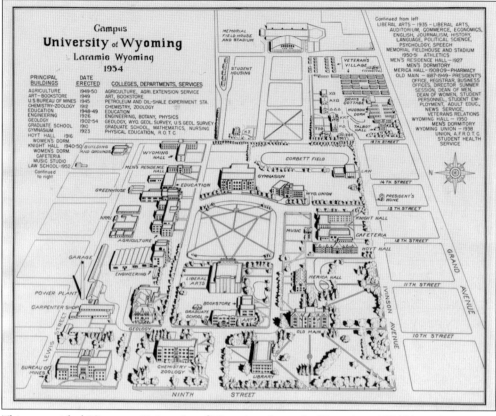

This map, titled "Campus, University of Wyoming, Laramie, Wyoming, 1954," is an interesting snapshot of the physical layout following the increase in student population. The growth in campus housing is evident, and the Veteran's Village occupies the part of the campus where today stand the high-rise dormitories. A variety of roads provide access to all areas of campus, which were later removed to create a pedestrian-friendly campus. The map also lists the year in which each of the principal buildings was erected. (UWL-GRH.)

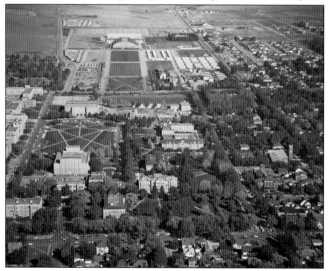

This 1956 aerial photograph of campus is nearly identical to the map above. The William Robertson Coe Library is shown under construction to the right of the Wyoming Union (center). The Science Building is just out of the picture, but both the Education and Agriculture Buildings are visible on the left side of the pasture. The campus went through a major building expansion after World War II. (UWPS.)

Four

PREPARE FOR COMPLETE LIVING

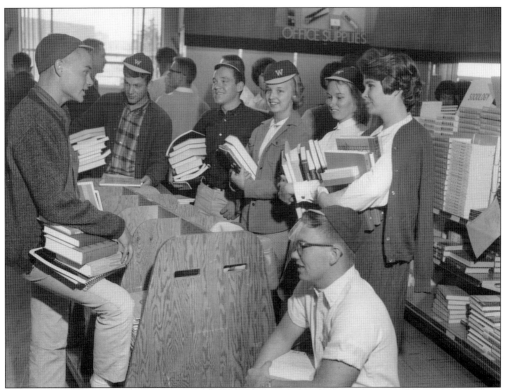

Students at UW were offered many different classes and other activities. They might have attended the Science Camp one summer or edited the student newspaper or taken classes in domestic science. One constant was the sight of freshmen wearing beanies. In this 1950s photograph, freshmen are purchasing books while dutifully wearing their beanies. According to a September 1967 article in the *Branding Iron*, freshmen only needed to don the head wear until the first home football game of the season. After the UW Cowboys scored their first touchdown, the students threw their beanies in the air and never had to wear them again. The tradition of beanies apparently goes back to 1908, when male students had to wear green caps and women green stockings. During the 1920s, freshmen had to wear the beanies until Homecoming. The 1923 student handbook states, "Wear your little yellow and brown caps. It is decreed and you have no choice in the matter." Beanies are no longer required for anyone. (AHC Photo Collections.)

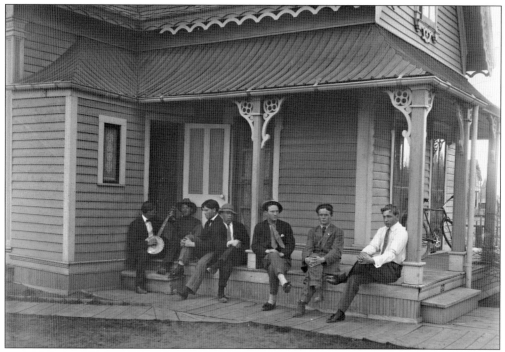

In the 1930s, under UW president Arthur G. Crane, the idea of a Fraternity Park was initiated. The decision to create the park stemmed from a desire to bring the various fraternities and sororities together from various residential areas throughout Laramie in order to, according to papers from a collection at the American Heritage Center, improve living conditions and "bring them more closely within the influence of the University." The Sigma Beta Phi fraternity house is pictured (above) in 1910. The first sorority house built in Fraternity Park was for Pi Beta Phi (below, around 1930) and was designed by university architect Wilbur Hitchcock. The agreement with the university administration required the exterior to "be of such design as to be in harmony with the other fraternity buildings in the Park." The other facilities, sidewalks, and landscaping were provided by the university. It was not until 1940 that other houses were built. (Above, S.H. Knight Papers, AHC; below, AHC Photo Collections.)

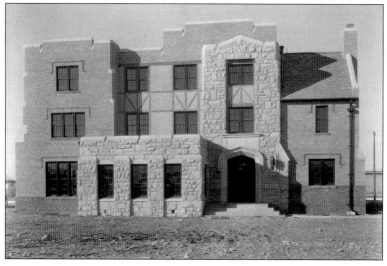

The Normal School was part of the university since its founding in 1887. In the early 1900s, the program was expanded to offer a four-year course resulting in a Bachelor of Arts in education. Identified here are Sorchie Moss, Thyra Thirkeldsen, Mattie Wallace, Mote Murray, Regina Horsh, Abbey Drew, Grace Drew, Edna Biddick, Etta Kennedy, and Mabel Sodergreen, the Normal School teachers for 1907–1908 year. (S.H. Knight Papers, AHC.)

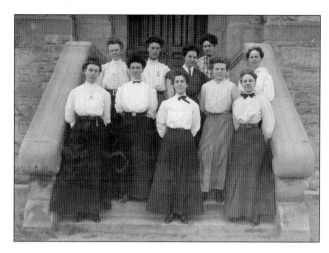

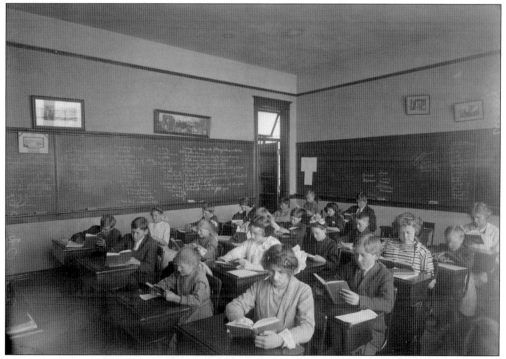

The Preparatory School was organized "for the benefit of students from counties not provided with complete high school courses." The 1897–1898 *University Catalogue* also states, "As soon as the various towns of the state possess well equipped high schools, this department of the University will be abolished." The Preparatory School became the Training High School in September 1913, and the name was changed to University High School the following year. According to the June 1915 issue of the *University of Wyoming Bulletin*, "This high school is maintained primarily for the purpose of affording opportunities for training teachers for the high schools of the State." It was variously known as the Training Preparatory School, the Secondary Training School, and the University High School. (S.H. Knight Papers, AHC.)

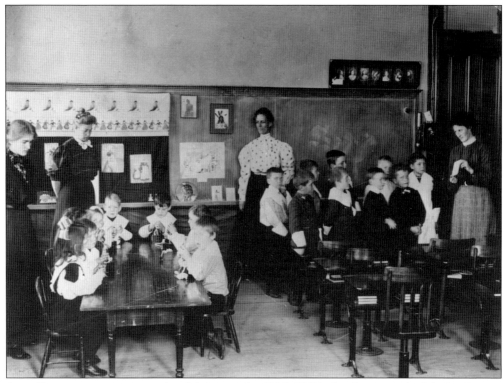

According to notes accompanying this image, the 1906–1907 school year marked the beginning of the student-teaching program at the University School. The teachers pictured here are, from left to right, Neva Nelson, Anne Reed, Ruth Adsit (the school's first principal), and Clara Prahl. The room was on the second floor of Old Main, known as "the primary room," which included grades one through three. (Clarice Wittenburg Papers, AHC.)

This is a fourth-grade class working on a "language activity" at University Elementary School. All the children in the class are engaged in writing, editing, or reading items for their wall newspaper. The student teacher at the back of the room is Miss Peterson. (Photograph by Herb Pownall, Clarice Whittenburg Papers, AHC.)

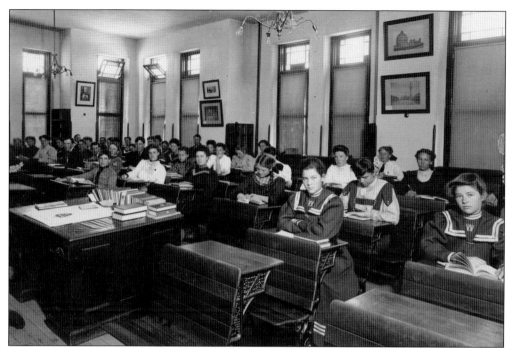

This 1908 English class shows Lucile and Agnes Wright (far right) in the foreground. Agnes was the first female editor of the *Wyoming Student*, UW's first literary publication. She was also the first female student to study engineering, graduating with a civil engineering degree in 1913. She studied journalism at Columbia University but returned to Wyoming when Columbia closed because of World War I. Moving to Fort Collins, Colorado, after marrying Archer Spring, Agnes began writing. Focusing on Wyoming and Western history, she was the author of 20 books. While in Wyoming, she served as state librarian and state historian. According to the Western Writers of America, Agnes also served as the state historian in Colorado—the only person to serve in that role for two different states. (S.H. Knight Papers, AHC.)

According to historian Deborah Hardy, UW president John Hoyt did not anticipate a special School of Music, which was established in 1895 and consisted of one instructor providing lessons with university-provided space and piano. This June 1896 image shows a music class. (S.H. Knight Papers, AHC.)

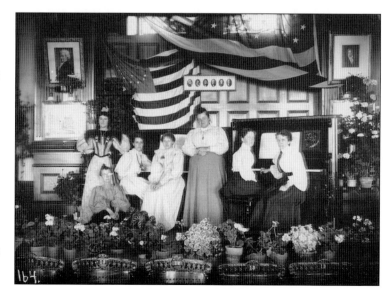

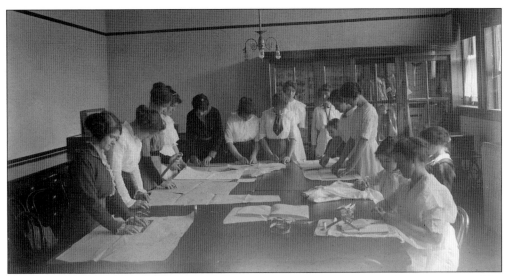

The State Federation of Women's Clubs requested that domestic science become a part of the university curriculum. The April 1908 issue of the *University Melange* included the catalogue of courses and stated, "The authorities of the University of Wyoming have recognized the demand for a broader education for young women, by introducing a course in Domestic Economy leading to the degree bachelor of science." This image shows a home economics class in 1911. (S.H. Knight Papers, AHC.)

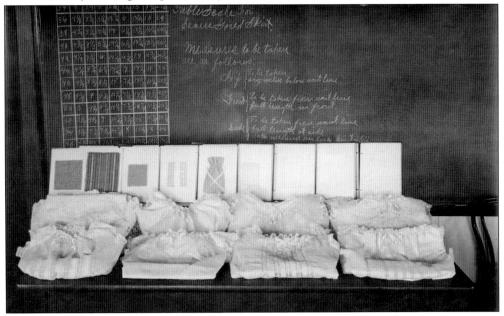

Three of the twelve courses offered in the new domestic science program were classified as "domestic art." This image, showing the work of a 1907–1908 domestic science class, is most likely from a textiles course that included "the study of fabrics, history, processes of manufacture and the development of these processes, economic value and their effect on social conditions. A study of a simple system of drafting, the taking of accurate measurements, the choice and economical cutting of materials and the making of plain garments, and the instruction in machine work." (S.H. Knight Papers, AHC.)

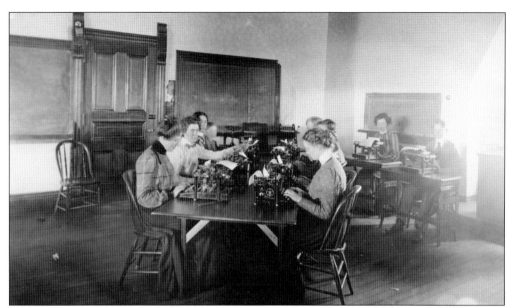

A School of Commerce with a three-year course of study opened in 1899. The 1903–1904 *Seventh Annual Catalogue* provided a small description of the program. There were two departments listed, bookkeeping and stenography, offering a large variety of classes, including six different bookkeeping classes as well as commercial and industrial geography, commercial arithmetic, penmanship and spelling, and correspondence and typewriting. This is a 1901 photograph of the business department. (S.H. Knight Papers, AHC.)

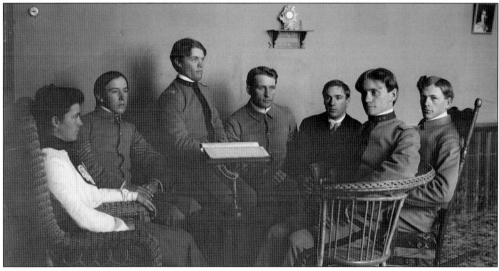

One of several student-produced publications, the *Wyoming Student*, founded in October 1898 by R.L. Rigdon, was a monthly literary magazine. Its first issue and many subsequent ones carried stories, poems, and articles written by students and faculty with a section containing news items and editorial comment. As a magazine, this publication continued in varying sizes and formats until 1913, when under the editorship of Agnes Wright it changed to a newspaper. With the March 14, 1923, issue the name was changed to the *Branding Iron*, a "name more fitting, both to its school and to its nature." Pictured here on February 11, 1904, are members of the editorial staff of the *Wyoming Student*. (B.C. Buffum Papers, AHC.)

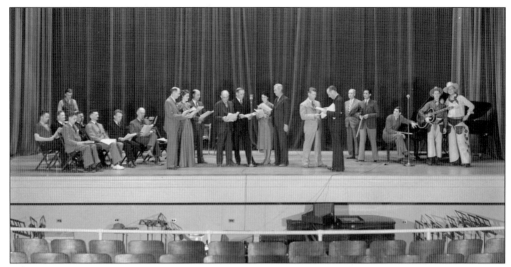

"The National Farm and Home Hour . . . comes to you today from the University of Wyoming in Laramie," began a radio broadcast on September 28, 1938, from the UW Auditorium to the nation. Part of the program was a dramatization of Stephen W. Downey's speech before the territorial legislature in 1886, when the bill to create the University of Wyoming was pending. Additional sketches included the student reception and kidnapping of UW president Arthur Crane upon his arrival in Laramie and the discovery of the presence of selenium in poisonous range plants by Prof. O.A. Beath. The transcript of the program is held in the Grace Raymond Hebard Collection in the UW Libraries. (Ludwig-Svenson Studio Collection, AHC.)

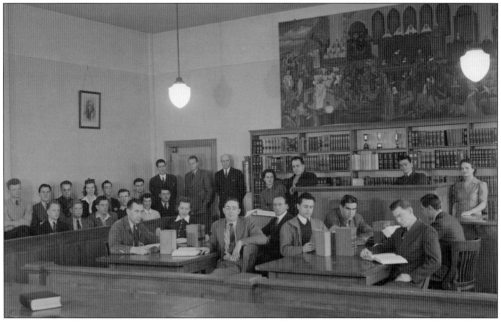

According to the 1922 *Wyo*, the university yearbook, a petition started among UW students resulted in the formal opening of the first law school on September 21, 1920. In 1922, the Potter Law Club was organized by Prof. Thurman Arnold and named in honor of Wyoming chief justice Charles N. Potter. This photograph of the club was taken in 1943. (Ludwig-Svenson Studio Collection, AHC.)

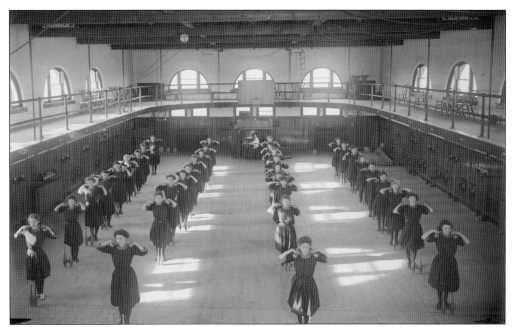

The October 1902 issue of the *Wyoming Student* began promoting the need for a gymnasium on the UW campus. Citing the great strides made by the university in the number of courses offered, increased volumes in the library, and erection of new buildings that addressed the intellectual needs of the student body, the article queried, "What have we done for their physical development?" The answer? Nothing. The campaign for a gymnasium continued with supporting articles by students and faculty. The February 1903 issue of the publication noted that the gymnasium bill was passed by the state legislature. The facility, which also included an armory, was located east of the Mechanical Arts Building and north of the football gridiron. The opening of the gymnasium was held on February 13, 1904. Above, a girls' gym class is in session in the "Little Gym" in 1908. The photograph below was originally published in the 1928 edition of the *Wyo* with the caption, "Dance of the Gloopsies." A thorough search of local newspapers failed to provide any additional information about it. (Above, S.H. Knight Papers, AHC; below, Ludwig-Svenson Studio Collection, AHC.)

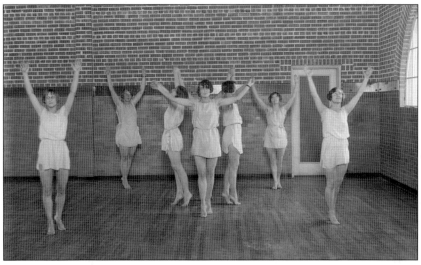

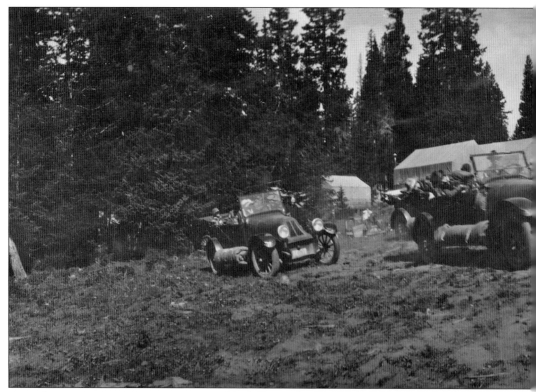

According to S.H. Knight biographer Frederick Reckling, the establishment of the Science Camp was "Doc" Knight's proudest achievement. A base for fieldwork for the study of geology, zoology, and botany, students from UW and across the country pursued their studies there. During the summer of 1923, the first camp was established at the head of Long Canyon. The result of that experience led to a cooperative arrangement between the geology departments of UW and Columbia University that lasted over 30 years. Following the second summer

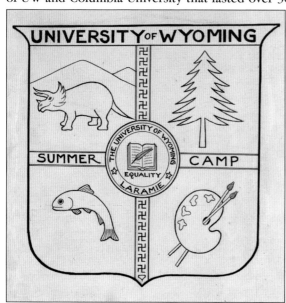

When the Science Camp first opened, there was no paved highway, only a dusty dirt road leading to it. Water was carried in buckets, and light was provided by kerosene lanterns. The logo used to identify the camp (pictured) represents the disciplines covered in camp courses. (S.H. Knight Papers, AHC.)

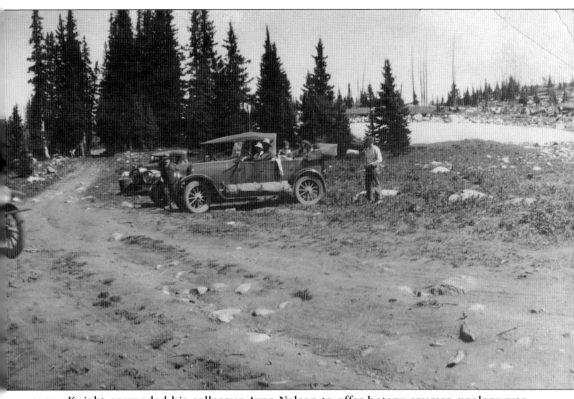

camp, Knight persuaded his colleague Aven Nelson to offer botany courses; zoology was added the next year. With the growth of the program, a permanent campsite was selected six miles west of Centennial on 27 acres obtained from the US Forest Service. This image shows one of the "fleets" used to transport students, faculty, and supplies to the various field locations. (S.H. Knight Papers, AHC.)

This undated map of the University of Wyoming summer Science Camp shows the layout and expansion of the facility. From 1935 to 1937, the WPA and the Civilian Conservation Corps (CCC) aided with construction. A 1948 article on the UW Science Camp described it as completed, with "a main lodge, four laboratory buildings, a bath house, forty dormitory cabins, and several service buildings." (S.H. Knight Papers, AHC.)

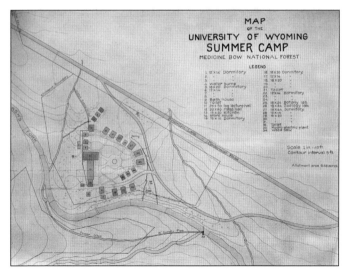

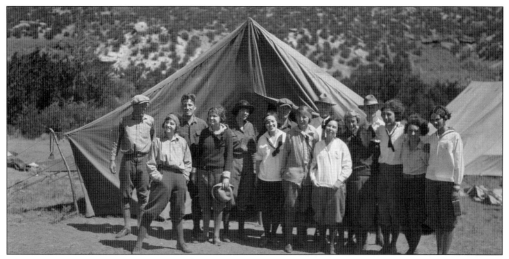

The campus newspaper, the *Branding Iron*, ran a lengthy story about the new courses offered to those attending summer school, stating that the university "has devised a plan whereby summer school students can enjoy the exceptional advantages afforded by the mountainous environs of Laramie for field study in geology, botany and zoology without interfering with residence study on the campus. . . . The field studies will be conducted from a camp which will be located in a very picturesque region twenty-five miles south of Laramie." According to Samuel H. "Doc" Knight, this camp was a half mile east of Camel Rock. This group is at Science Camp at Sand Creek in 1924. (S.H. Knight Papers, AHC.)

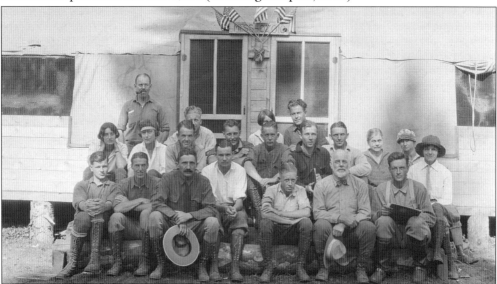

The success of the first two camps justified the beginning of a more permanent camp. A site selected in the fall of 1924 was 30 miles west of Laramie in the Medicine Bow Mountains. The road from Centennial to Brooklyn Lake had recently been opened to automobile travel, and construction of permanent buildings began that year. Teachers and students in Geology 109S from 1924 are pictured here. They are, from left to right, (first row) ? Briggs, ? Bradway, Samuel H. Knight, ? Keppel, ? Spaulding, Dr. ? Kemp, and ? Burder; (second row) D. Pearson, E. Chatterton, ? Miller, ? Palmer, ? Kellogg, O. Knight, ? Kemp, ? Jacobi, and ? Thode; (third row) ? Seton, ? Hubbard, ? Gariepy, C. Chatterton, and ? Spears. (S.H. Knight Papers, AHC.)

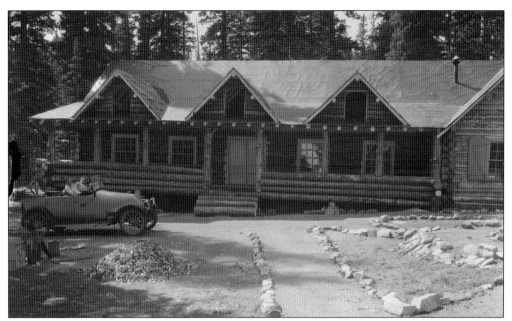

Construction of the Science Camp began on June 1, 1925, when workers cleared the site and erected tent houses. This established a tradition of construction maintenance that lasted throughout the history of the camp. Each year, 8 to 12 working scholarships were awarded to deserving majors in the subjects taught at the camp. Their duties also included driving cars, camp chores, and cutting firewood in preparation for the next session. Construction of the lodge was the most ambitious of the building projects. The north wing was built in 1929, the central assembly room and kitchen in 1930, and the dining room in 1935. (S.H. Knight Papers, AHC.)

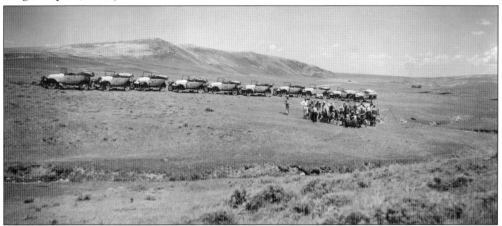

Samuel H. "Doc" Knight, in a brief history of the Science Camp, stated, "One of the most challenging problems during the earlier years of the camp was adequate transportation." The purchase of new vehicles was not within the budget. In the spring of 1927, the camp began acquiring "what was probably the most picturesque caravan to travel the roads of Wyoming." Used Franklin touring cars were purchased for the camp, and by 1929 the fleet contained 11 used Franklins. Knight continued, "These cars were painted a bright yellow with an appropriate dinosaur seal on the door." Look closely, as this photograph could very possibly be that Franklin fleet with the dinosaur emblems. (S.H. Knight Papers, AHC.)

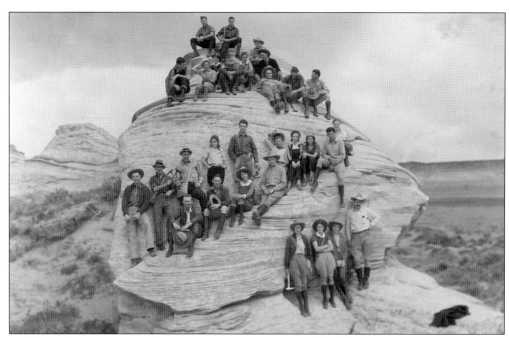

Sand Creek is a stream in Albany County, Wyoming, noted for the "most spectacular examples of cross-bedded sandstone and 'topple blocks' in North America." It was listed on the National Registry of Natural Landmarks in 1984. According to that listing, "Excellent geological, paleontological, and botanical features mark the importance of the area." The unique formations of Sand Creek belong to the Casper Formation. Dr. S.H. Knight first wrote about the geology of this area in the southern Laramie Basin in the 1929 issue of *University of Wyoming Publications in Geology*. As seen in these images, the area was a popular setting for geology field trips—a tradition that continues. Pictured here are students in the geology field class in an undated photograph and provides a fine example of the cross-bedding of the ancient dunes. The lower image is of the 1955 geology field class. (Both, S.H. Knight Papers, AHC.)

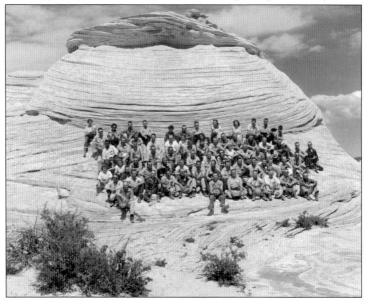

Pictured here are Helen Lane and Alice Ellen Ford sitting in the doorway of one of the Science Camp cabins on September 21, 1930. Doc Knight's daughter Eleanor Knight Keefer recalled meeting Mrs. Herbert Hoover (Lou Henry) at the Science Camp when she was eight or nine years old. Mrs. Hoover, who served two non-consecutive terms as president of the Girl Scouts, was searching for a location for a national Girl Scout retreat. As the first female to graduate from Stanford University with a degree in geology, she learned of the camp from her geology connections. The Girl Scout organization was important to the former first lady. According to *Uncommon Americans: The Lives and Legacies of Herbert and Lou Henry Hoover*, "Always she wanted for the girls what she wanted for herself—and what she wanted was camping." While the Science Camp was not selected for the retreat, the Girl Scouts National Center West was located near Tensleep, Wyoming, from 1968 to 1989. (S.H. Knight Collection, AHC.)

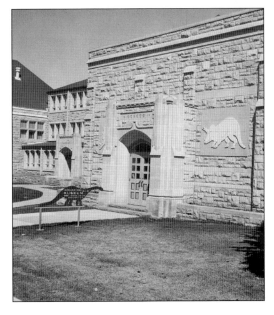

An addition to the east side of the Science Hall provided new space for the Geological Museum. Renovation of the original building moved the main entrance to the south, and the museum gained its own entrance. To facilitate this expansion, the old Commons Building was razed. The Geology Library was located on the first floor, along with administrative offices. S.H. Knight is responsible for the dinosaur artwork on the outside walls. When the Earth Sciences Building was added in the 1990s, the Geology Library underwent renovations thanks to the generosity of the Brinkerhoff family. It is now known as the Brinkerhoff Earth Resources Information Center. During the summer and fall of 2012, the Geology Museum was renovated and expanded. (UWPS.)

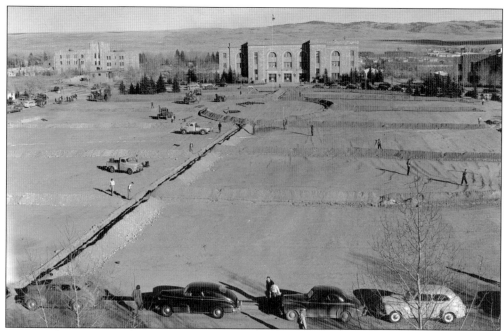

George Duke Humphrey, the 13th president of the University of Wyoming, made a huge impact on the appearance of the campus. Appointed in June 1945, he compiled a list of goals the university should strive to achieve. The list included colleges that should be established, additional physical facilities that should be added, and services that must be provided to the state as part of a total university program. It also included a plan for beautification of the campus. One his primary objectives was "landscaping the muddy expanse of ground" between the Arts and Sciences Building, Half Acre Gym, and the Student Union. Completed in 1950, the grassy area was dubbed "Prexy's Pasture." This image shows the construction of the pasture in 1950. (AHC Photo Collections.)

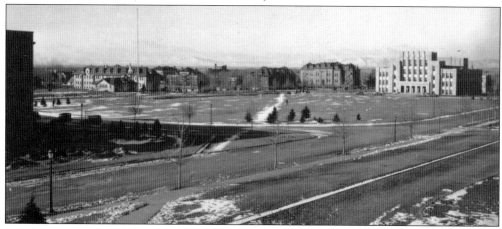

A unique perspective of Prexy's Pasture is provided in this c. 1936 panoramic view taken from the northeast corner just north of Half Acre Gym. Even in this winter photograph, the irrigation system used to water the campus is visible running parallel to the sidewalk. This system was in use until the late 20th century, when it was replaced by sprinklers. The irrigation system was a unique way to keep the campus green, and many alumni fondly recall seeing the small streams of water flowing through campus. (Seymour Bernfeld Papers, AHC.)

This c. 1928 aerial view shows the major structures on campus before the Great Depression. Government programs like the WPA, the NYA, and the CCC operated on campus and in the Laramie area. East of campus is open prairie, and the Sherman Hills are in the shadows. The Cooper Mansion is to the right of Corbett Field, and the Ivinson Hospital, which was razed in 2012, is in the lower right across Ivinson Street from Old Main. (AHC Photo Collections.)

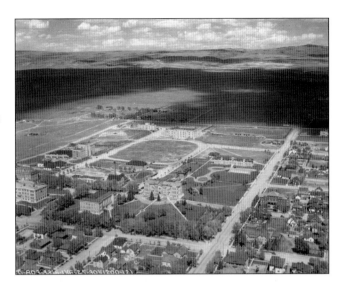

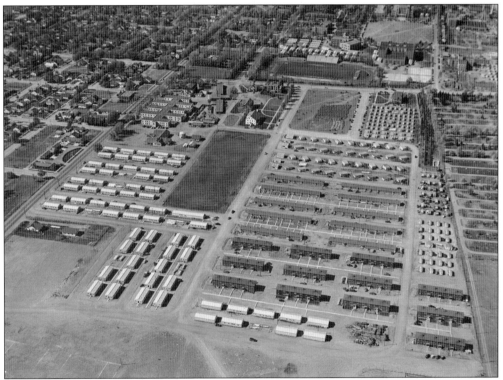

At the end of World War II, many young men who postponed their educations to serve their country returned to college. Such a large increase in the student population resulted in the need for increased accommodations as well as classrooms. To meet this need, temporary structures were placed all over the UW campus. This 1947 aerial view shows the east end of the campus filled with Butler huts, trailers, and prefabricated houses. In 1945 and 1946, the university purchased several acres from the Episcopal church of Wyoming, which included the old Cathedral Home for Children buildings and grounds. Some of these buildings, such as Talbot Hall and Dray Cottage, were used for additional housing. (AHC Photo Collections.)

Coolest Summer School in America"

&

The University of Wyoming

SUMMER QUARTER 1935
First Term . . . June 17–July 24
Second Term July 25–August 30

University Summer Camp
IN SNOWY RANGE

FIELD COURSES IN:

<div align="right">

BOTANY GEOLOGY
GENERAL SCIENCE
ZOOLOGY

</div>

JUNE 22 - JULY 27

Summer courses were provided early in UW's history. Attending summer school in Laramie became popular as course offerings increased, and marketing brought in many participants. In 1954, an article in the _Alumnews_ described the variety of opportunities available: Orchestra Camp was held at the Recreation Camp near Centennial, the Institute of International Affairs offered a guided tour through Europe led by Dr. Gale McGee, the Jackson Hole Biological Research Station was available for researchers, and a summer conference on American Studies ran from mid-June to mid-August. The University of Wyoming hosted the "Coolest Summer School in America." (UWL-GRH.)

Five

ROAMING THE UNIVERSITY OF WYOMING

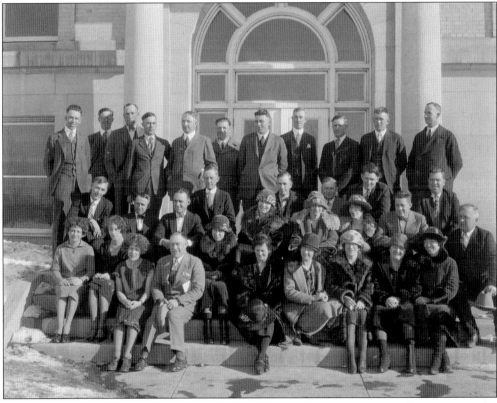

The *University Bulletin* described UW's statewide outreach mission in 1914 by stating: "The University of Wyoming wishes to meet the educational needs of the people of Wyoming in all feasible ways. The services of the faculty, the resources of the libraries and laboratories, should be made available not merely for the young people who come to its campus, but also for citizens in their homes throughout the State." The Agriculture Extension Service has been a major part of that outreach. This image is of the extension workers from the 1925–1926 academic year. Today, the extension service has offices in each of the state's 23 counties and on the Wind River Reservation. (Ludwig-Svenson Studio Collection, AHC.)

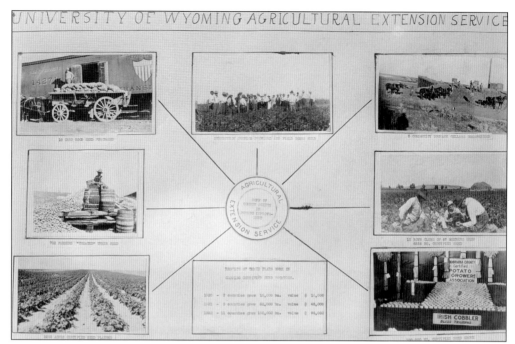

This Agricultural Extension Service Poster from 1922 illustrates the success of growing potatoes in Wyoming. The 1890 Wyoming Legislature authorized UW's College of Agriculture to receive federal funds authorized by the Morrill Act for each state and territory that maintained an agricultural college. This allowed the college to increase the number of faculty and, in 1891, establish the Wyoming Agricultural Experiment Station at Laramie, with substations at Lander, Saratoga, Sheridan, Sundance, and Wheatland. (AHC Photo Collections.)

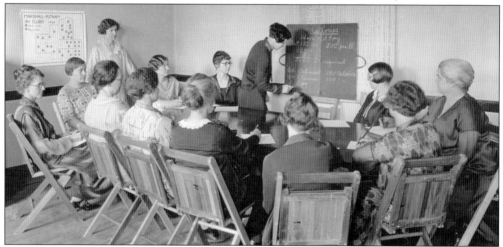

A local extension leader demonstrates to a nutrition group the number of calories needed by a 14-year-old boy. Agricultural Extension Service nutritionist Evangeline Jennings completed an economic survey in Goshen County in 1930 that detailed the quantity and type of food produced on the farms and how much food was purchased. The survey report also included a typical food budget. This survey and report was the basis for nutrition meetings around the state for the following two years. Jennings also provided nutrition demonstrations at the Leaders' and Mothers' Recreation Camps. (AHC Photo Collections.)

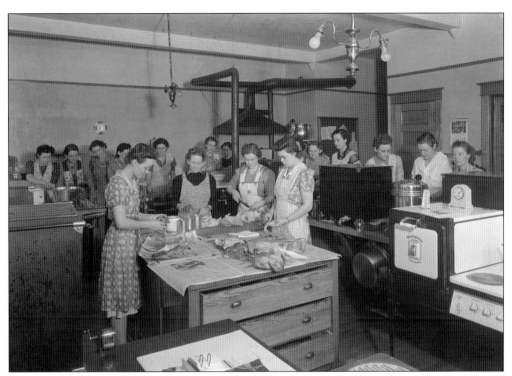

In the 1939 photograph above, an agricultural extension agent demonstrates to a group of women how to can meat products. Food preparation and preservation were popular topics covered by the extension service. The graph below illustrates the number of men and women, along with the number of boys and girls clubs, reached by the extension service in 1924. The Smith-Lever Act of 1914 stipulated "that Cooperative Agricultural Extension work shall consist of the giving of instruction and practical demonstrations in Agriculture and Home Economics to persons not attending or resident in said Colleges in the several communities, and imparting to such persons information on said subjects through demonstrations, publications, and otherwise, and this work shall be carried on in such a manner as may be mutually agreed upon by the Secretary of Agriculture and the State Agricultural College or Colleges receiving the benefits of this Act." (Above, Ludwig-Svenson Studio Collection, AHC; below, S.H. Knight Papers, AHC.)

UNIVERSITY of WYOMING
EXTENSION SERVICE

Individuals reached by the Service in 1924

Boys and Girls Clubs	1500
Women	4000
Men	7000

Better methods adopted by Wyo. Homemakers

1919	450
1924	5,054

Service in 5 Years 16,284

Attendance Clothing Meetings

1922	1,038
1923	4,092
1924	10,118

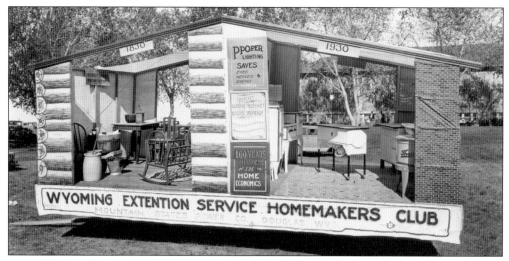

An exhibit by the Wyoming Extension Service Homemakers Club illustrates the progress made in the home from 1830 to 1930. Improvement in the kitchen was focus of the extension service. In 1920, a project in home management was titled "Household Conveniences." As part of this, homemakers demonstrated iceless refrigerators and pressure cookers. By 1923, the service sponsored Kitchen Contests, where county agents and project leaders visited kitchens and discussed improvements that could then be completed in six to eight weeks. This project ended in 1924 after 45 communities participated and 153 result demonstrations were completed. More than 550 women attended meetings on kitchens, and 148 kitchens were planned and rearranged. (WSA.)

The university exhibited the variety of crops grown at the Wyoming Experiment Station at Laramie in September 1910. The early work of the experiment stations was that of dry farming, irrigation, and high-altitude plants and fruit. In 1902, issues of range management were studied at the stations. The experiment station bulletins also included such topics as botanical surveys by Aven Nelson and Wilbur Knight's reports about Wyoming geology and Wyoming birds. (S.H. Knight Papers, AHC.)

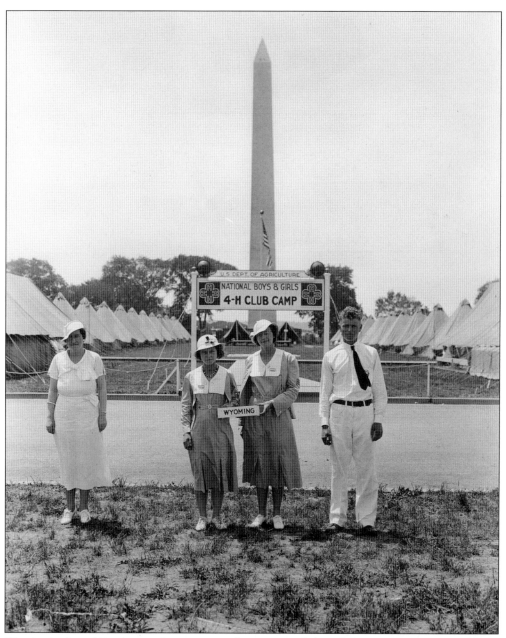

The Agricultural Extension Service actively supported 4-H clubs around the state. These Wyoming 4-H members attended the National Boys and Girls 4-H Club Camp held in Washington, DC, and sponsored by the Department of Agriculture. The national club camps ran from 1927 to 1956. Wyoming began sending representatives in 1934. During the camps, attendees heard lectures from national leaders, took field trips to various historic sites, and made friends from other parts of the country. The primary purposes of the camp were "to reward and develop outstanding junior leaders in club work; to acquaint club members with their government, and to acquaint Washington with club work; and to provide a convenient time and place for a meeting of all state leaders, both north and south." (AHC Photo Collections.)

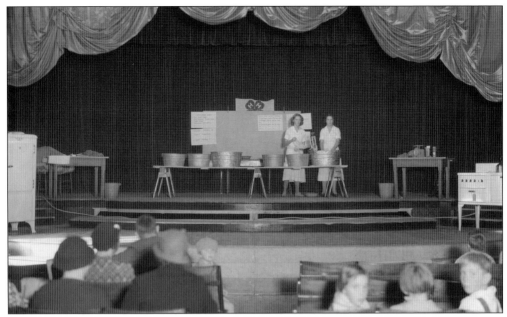

At a meeting of the 4-H club in Laramie in 1933, two young ladies in a mocked-up kitchen demonstrate laundering techniques. In 1928, Burton Marston became the state agent in club work for the Agricultural Extension Service. A 1920 graduate of UW with a degree from the College of Agriculture, Marston had previously been the Platte County club agent and, for seven years, county agent in Johnson County. Except for four years during World War II, Marston served as the state agent in club work until 1958. He brought regional and national acclaim to Wyoming's 4-H club. (AHC Photo Collections.)

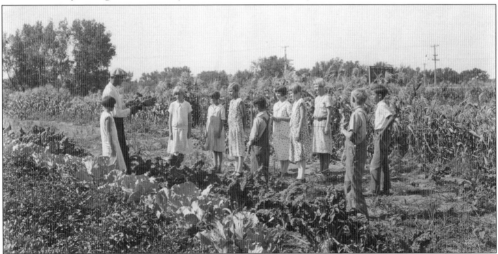

In 1934, an extension agent discusses the variety of crops grown in Goshen County. Just a year earlier, because of the effects of the Great Depression, the extension service almost lost all of its funding. The 1933 legislature needed to reduce funding, and some legislators looked to eliminate some colleges and departments. A bill was introduced to cut all funding to the Agricultural Extension Service. This bill did not pass, and the service received a budget of $61,000 for the biennium; during the previous biennium, the service received $145,000. At the same time, faculty salaries were cut by $70,000. (AHC Photo Collections.)

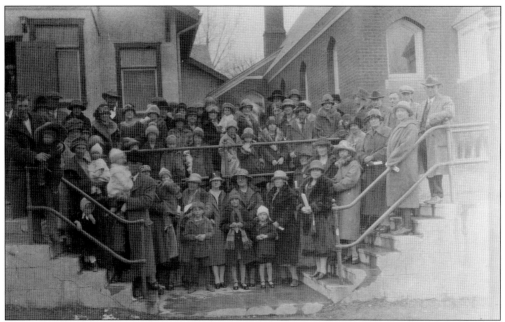

Several hundred people attended the second-annual Farmer's Roundup held in Buffalo and Kaycee. The Johnson County extension agent was involved in the event, and UW faculty spoke on various topics. Lectures presented the first day were about farm crops and dairying, along with a talk titled "Elimination of Fatigue in Housework." The following day, participants learned about ranch and range management and how to raise hogs. Many judging contests were also held at the event. (AHC Photo Collections.)

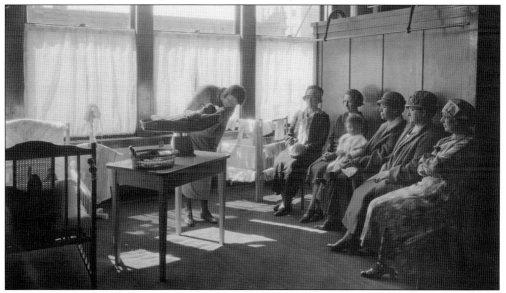

Local women often demonstrated various techniques, like this home demonstrator who is illustrating the importance of weight in caring for a baby. Henrietta Kolshorn became Wyoming's first home demonstration agent leader in 1915. Her programs included such topics as the proper feeding of children, how to clean clothing, and the proper use of a pressure cooker. (AHC Photo Collections.)

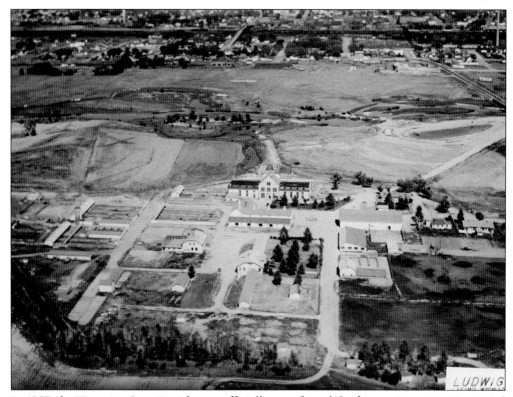

In 1907, the Wyoming State Legislature officially transferred the former Wyoming Territorial Prison and later the Wyoming State Prison (from 1872 to 1903) to UW's College of Agriculture to serve as an experimental stock farm. The university was already using the property as a farm, but that year—besides the official transfer—the legislature also allocated $5,000 to repair and equip the farm. Much renovation was done: the steel cells in the south wing were replaced with a wool scouring plant, and the north wing cells were converted into a modern cattle barn. The stock farm was used to teach students and livestock producers from Wyoming and surrounding states about beef, sheep, sheep shearing, and wool. The farm also maintained dairy cattle, pigs, and poultry at various times and had living facilities for staff and students. The university ended operations at the farm in 1989. It is now a state historic site and was restored as the Wyoming Territorial Prison. First operated by a private corporation, the state assumed control in 2004, and it is now known as the Wyoming Territorial Prison State Historic Site. The image above offers an aerial view of the stock farm. (Above, Ludwig-Svenson Studio Collection, AHC; below, WSA.)

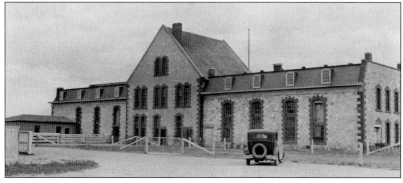

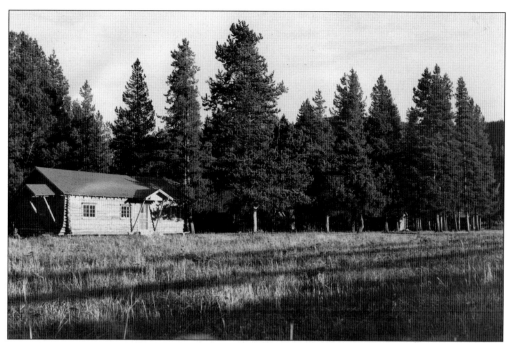

In 1953, UW assumed the administration of the Jackson Hole Research Station located in Grand Teton National Park. Started in 1947 jointly by the New York Zoological Society, Wyoming Game and Fish Commission, and the Jackson Hole Preserve, the research station has long been an important part of the UW zoology and physiology department's research mission. The station allows for investigations in the biological, physical, and social sciences in national parks in the Rocky Mountain region. Dr. L. Floyd Clarke, head of the department in 1953, became the director of the research station that year. During his term as director, Clarke greatly improved the facilities, and he facilitated a special lease permit with the National Park Service (NPS) in 1964. In 1977, the station moved to the NPS AMK Ranch in Grand Teton National Park, where it is currently located. Pictured is the original research station. (L. Floyd Clarke Family Papers, AHC.)

Dr. Alan A. Beetle (standing) was one of the UW faculty members who conducted studies at the Jackson Hole station. Dr. Beetle was a professor of range management. Here, he is presenting a talk at the research station, which is open from mid-May to mid-October. (L. Floyd Clarke Family Papers, AHC.)

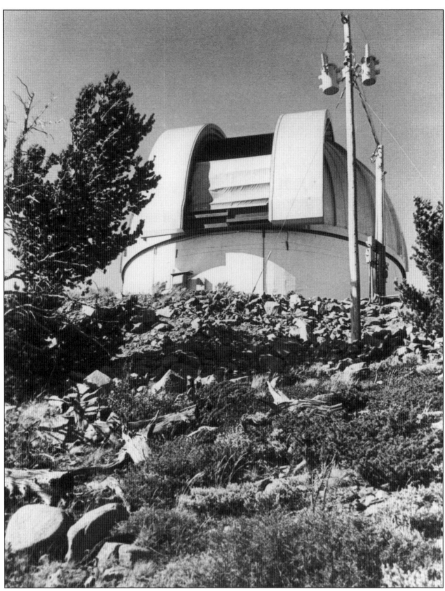

The University of Wyoming came to the forefront in astronomy with completion of the Wyoming Infrared Observatory (WIRO) in September 1977. Built on Jelm Mountain, located west of Laramie, at a cost of $1.6 million derived from a combination of state and federal funds, the infrared telescope is used to study infrared energy levels given off by distant stars. UW faculty members and students, along with researchers from other universities, have used the facility, which is administered by the UW Department of Physics and Astronomy. The university held the dedication of the observatory on July 28, 1978, at Washakie Center on campus. According to the *Laramie Daily Boomerang*, UW president William Carlson saw the observatory as a "unique tool for teaching and one which will greatly enhance UW's academic programs." Geoffrey Burbidge, noted British-born astrophysicist and then director-designate of the Kitt Peak National Observatory at Tucson, Arizona, presented the main address. He said that Wyoming would be one of the major centers for astronomy in the country. (Wyoming Infrared Observatory Records, AHC.)

Six

ON THE HEIGHTS

The University of Wyoming has a long athletic tradition. When teams visit Wyoming, they know they will be playing at 7,200 feet above sea level. According to the April 1920 *University Catalogue*, "The unique distinction of being located at a higher altitude than any other great educational institution in the nation belongs to the State University of Wyoming." This distinction is no longer held by UW. The brown and gold colors are based on the brown-eyed susan, a flower found in southeastern Wyoming. There are different versions of why UW teams became the Cowboys, but according to a September 1947 issue of the *Alumnews*, E. Deane Hunton, dean of the College of Commerce, claimed credit for coming up with the name in 1909. He also said he designed the logo for the baseball team that year. And, of course, all Cowboy and Cowgirl fans know the fight song, "Ragtime Cowboy Joe": "Cause the western folks all know, he's a high-falootin', rootin', tootin', son of a gun from ol' Wyoming, ragtime cowboy, talk about your cowboy, Ragtime Cowboy Joe." (*Wyoming Student*, GRH.)

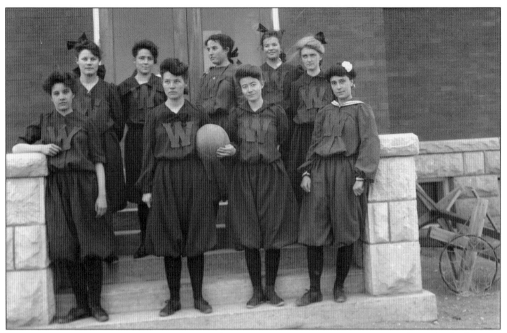

With the construction of the university's first gymnasium, completed in 1904, basketball came to the UW campus. The Cowgirl basketball team posed for this photograph on January 5, 1905. Pictured from left to right are (first row) Grace Peabody, Ethel Ponting, Mary Marshall, and Edith Betts; (second row) Gertrude Ponting, Ida Irongheldt, Abey Drew, Miriam Corthell, and Nevo Nelson. (B.C. Buffum Papers, AHC.)

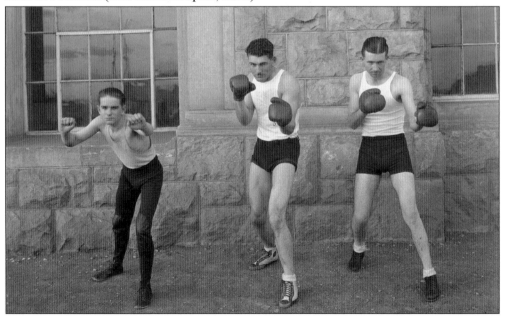

Students enjoyed other sports, as seen in this 1930s photograph of two boxers and a wrestler outside Half Acre Gym. John Corbett, hired as the university's first director of the physical education department in 1915, introduced boxing, wrestling, fencing, and gymnastics. (Ludwig-Svenson Studio Collection, AHC.)

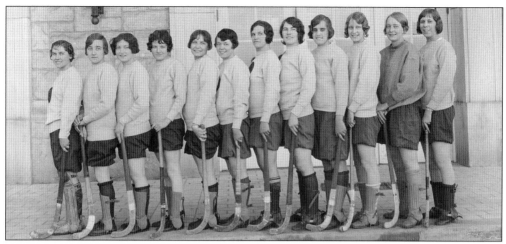

The women's field hockey team posed for this photograph in 1928. As reported by the *Branding Iron*, they played their last game of the 1928 season in December, traveling by car to Greeley, Colorado, where they faced the team from the Colorado Teachers' College. Even though UW led 1-0 at halftime, during the second half the Greeley team "made long drives keeping the ball in constant play up and down the field," and UW lost 4-1. After the game, the Wyoming players "were entertained at a tea given by the Women's Athletic Association of Greeley." (Ludwig-Svenson Studio Collection, AHC.)

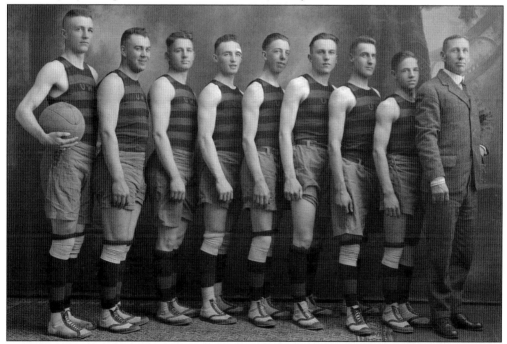

These young men represented UW on the 1919 basketball team. On March 11, 1919, the university YMCA held a banquet in their honor. One hundred students, faculty members, former students, and alumni attended the event. W.T. Watson, secretary of the YMCA, served as toastmaster. The *Wyoming Student* recorded the details of this event: "Talks were given by Dr. Aven Nelson, president of the University; Milward Simpson, representing the team; [and] Ralph McWhinnie, representing the 'scrubs.' " (Ludwig-Svenson Studio Collection, AHC.)

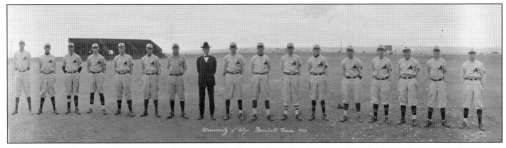

This image depicts the 1920 Wyoming Cowboys baseball team. The following year, the team joined the Rocky Mountain Conference. According to an article in the *Wyoming Student*, "The game is still in its embryo stage here as a major sport, it is climbing the ladder of student interest fast, however." The team's record that year was five wins and four losses. Two of the games were non-conference games. One writer blamed the not-so-successful year on bad weather conditions and a "rockpile of a practice field"—a new practice field was available the next year. One of the players (fourth from left) was Milward Simpson, better known as "Simp." He went on to become governor of Wyoming and also served in the US Senate. The university ended its baseball program in 1996. (AHC Photo Collections.)

Milward Simpson was one of the best athletes ever to play at the university. He served as captain of the baseball, basketball, and football teams during his years at UW (1917–1921). At the beginning of the 1921 baseball season, Simp was described in the *Wyoming Student* "as a star fielder last year and intends to be the same thing this year. He's hard to beat in that part of the diamond, and utterly fails when it comes to missing the descending sphere." After graduating from UW, Simpson earned a law degree from Harvard University and then began a law practice in Cody, Wyoming. He went on to serve in the Wyoming House of Representatives and was elected governor in 1954, serving one term. He served in the US Senate in the 1960s. Simpson was a member of the UW Board of Trustees for many years. (Ludwig-Svenson Studio Collection, AHC.)

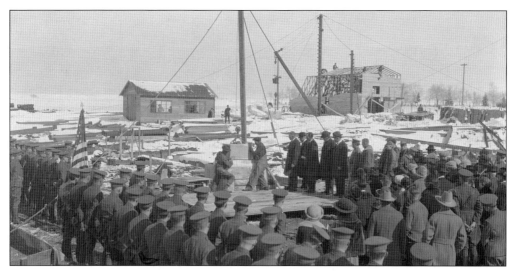

A crowd gathered during May 1903 to watch the laying of the cornerstone of the Gymnasium and Armory Building. The state legislature appropriated $15,000 for the building, which was designed by Cheyenne architect William Dubois. The UW Board of Trustees awarded the construction contract to W.H. Holliday Company of Laramie. The building had an interior of 90 feet by 45 feet. The lower floor was used for drill and as a gymnasium. The gallery running along the walls above the floor was used for a running track and held 300 spectators during basketball games. The building opened on February 13, 1904, with a cadet ball. According to the November 14, 1904, issue of the *Laramie Boomerang*, "There were over three hundred people present, but the hall is so large that there was no crush of any kind, and the gallery made a most advantageous place for spectators." (Ludwig-Svenson Studio Collection, AHC.)

The 2006–2007 UW Cowgirl Basketball team won the NIT championship in 2007. The team tied for second in the Mountain West Conference and then won six games in the tournament, all played in the UW Arena Auditorium. The 15,465 fans who witnessed the championship game saw the Cowgirls defeat the University of Wisconsin 72-56. The attendance was the second highest ever for a women's NIT game. Wyoming's Hanna Zavecz, from Australia, was selected as the tournament's MVP. (University of Wyoming Intercollegiate Athletics Collection, AHC.)

The 1934 UW basketball team was one of the best teams of its era. The "Punchers," as they were often called, had played well for quite a few years. An article in a 1934 issue of the *Branding Iron* stated that the "Cowboys have maintained a fine record for nearly twenty years. . . . [the team has been] constantly among the leaders of the Rocky Mountain Conference." The Cowboys became conference champions after defeating Brigham Young University in a three-game championship played in Half Acre Gym. In this photograph, Wyoming coach Willard A. Witte (left) receives the Denver Post Trophy for the conference championship as the team looks on. The team went on to place second in the national Amateur Athletic Union tournament. When the team returned to Laramie, they were greeted by 4,000 fans, and the Laramie High School band and the ROTC band led the parade to campus. Two Cowboys, Eddie McGinty and Art Haman, were selected for the All-American team. (AHC Photo Collections.)

Curt Gowdy, born in Green River, Wyoming, lettered in basketball and tennis for three years at the university. He graduated in 1942 with a degree in business statistics and briefly served in the Army Air Forces. Gowdy went on to a national career as a sports broadcaster. By 1951, he became the lead announcer for the Boston Red Sox. For years, he covered AFL and NFL games, as well as a number of Olympic Games. For many years, Gowdy hosted the television program *The American Sportsman*. The state park between Laramie and Cheyenne was named for Gowdy in 1972. (Ludwig-Svenson Studio Collection, AHC.)

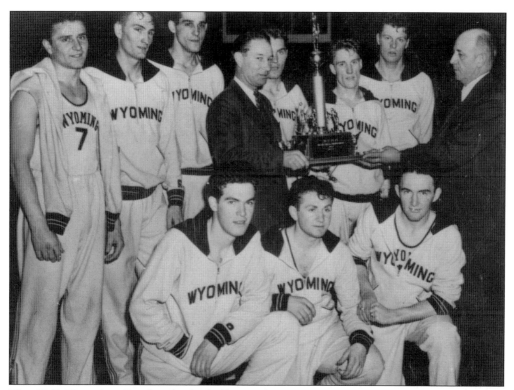

The 1943 Wyoming Cowboy basketball team became national champions with a victory over Georgetown University in the championship game. With Everett Shelton as coach that year, the Cowboys won the conference championship with a three-game sweep of Brigham Young University in the championship series. Invited to the NCAA tournament, the Cowboys defeated Georgetown 46-34 in front of 13,000 fans at Madison Square Garden. The Cowboys then played NIT champion St. John's University, again in Madison Square Garden, and won 52-47. The game was a benefit for the Red Cross, and it raised $26,000. One of the stars of the 1943 team, Kenny Sailors, was selected as an All-American. All but two of the team members were from Wyoming: Milo Komenich, from Gary, Indiana, and Don Waite, from Scotsbluff, Nebraska. (AHC Photo Collections.)

Kenny Sailors was one of the stars of the 1943 national champion UW basketball team. He was selected as the MVP of the NCAA tournament that year, as well as the College Basketball Player of the Year. He also is widely recognized as one of the originators of the jump shot. After the 1943 academic year, Sailors served in the Marines before returning to UW in 1946 and continuing his basketball career, again being named College Basketball Player of the Year. He played professional basketball from 1946 to 1951 and then returned to Wyoming and served one term in the Wyoming House of Representatives during the 1950s. After living in Alaska and Idaho, he returned to Wyoming for retirement. Sailors was inaugurated into the National Collegiate Hall of Fame in November 2012. (Ludwig-Svenson Studio Collection, AHC.)

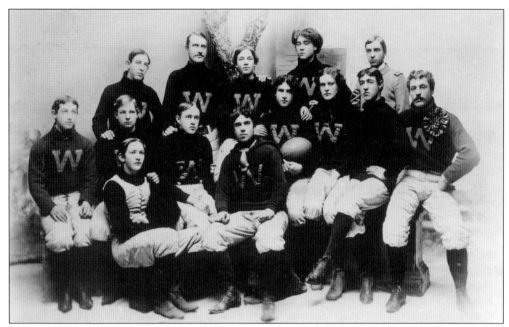

Football has long been a favorite sport at UW. The 1896–1897 team shown here was one of the first university football units. Beginning in 1893, the UW football team mainly played local teams, such as the local Laramie Eleven and the Cheyenne High School team. By 1895, the team was looking for out-of-state opponents and played schools like the University of Northern Colorado and Denver Manual High School. (AHC Photo Collections.)

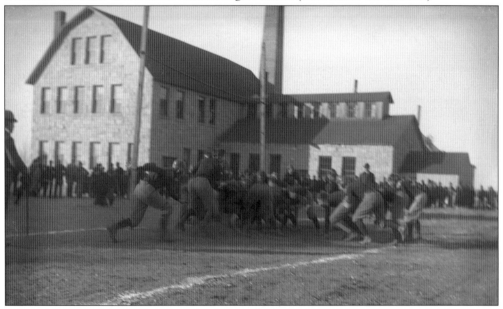

This photograph shows a football game on the UW campus in 1900. At the time, the team was not successful, although, according to Deborah Hardy in *Wyoming University: The First Hundred Years, 1886–1986*, the team "still managed well against high schools, the Laramie Athletic Club, and (in 1904), the UW faculty. The season record by 1914 was twelve won, eight lost, and two tied. Some seasons saw only one or two games." (S.H. Knight Papers, AHC.)

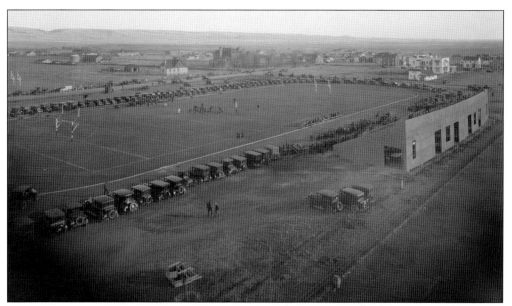

Automobiles surrounded what was then called University Field for the 1926 homecoming game. A *Branding Iron* writer saw this game as the "biggest and best Home Coming in the history of the school. . . . It is celebrating the realization of the achievement of our school in becoming one of the most respected and most highly rated institutions in the Rocky Mountain region. . . . In attendance, athletics, scholarship, pep, and progressive spirit our Cowboy school now ranks way to the fore." The Cowboys tied the Utah (later Utah State University) Aggies in the game, 6-6. (Ludwig-Svenson Studio Collection, AHC.)

Many fans watched the Wyoming Cowboys play at Corbett Field in 1948. The field was named for John Corbett, who coached the football team from 1915 to 1923. The John Corbett Physical Education Building, dedicated in 1976, was also named for him. Corbett was inducted into the UW Athletic Hall of Fame in 1995. (WSA.)

Diehard Cowboy football fans followed the team in various ways. When the Wyoming Cowboys played at Montana State University on October 31, 1925 (Wyoming was then part of the Rocky Mountain Conference), hundreds of UW football fans sat in Half Acre Gym watching a Play-o-Graph, which provided game updates; the Cowboys won 7-0. (Ludwig-Svenson Studio Collection, AHC.)

The story of UW mascot Cowboy Joe began in 1950, when the Farthing family of Cheyenne donated a young pony. Cowboy Joe attends all UW football games at War Memorial Stadium and trots around the field after each Cowboy touchdown. Today, Cowboy Joe IV participates in parades around the state and can be seen in Tailgate Park before home football games. (WSA.)

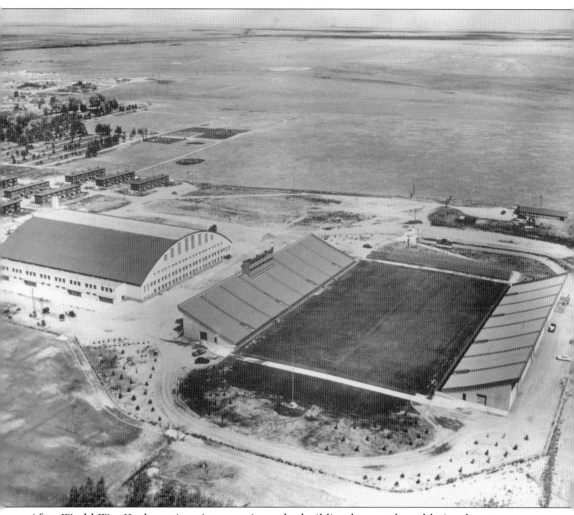

After World War II, the university experienced a building boom; the athletics department benefited with the construction of War Memorial Stadium and Fieldhouse. Spiegelberg Lumber and Building Company of Laramie received the construction contract, and the university broke ground on March 1, 1950. The first UW football game was played in the stadium on September 16, 1950, when UW defeated Montana State University 61-13 in front of 6,000 fans. The stadium dedication was held at the game against Southwest Conference favorite Baylor University the following week, on September 23. The 18,000 who attended the game witnessed the laying of the field house cornerstone and of the stadium's plaque. The two main speakers were acting governor Arthur G. Crane, former president of UW, and UW Board of Trustees president Milward Simpson. The Cowboys defeated Baylor 7-0. That year, the Cowboys went undefeated, won the conference championship, defeated Washington and Lee University 20-7 in the Gator Bowl, and were ranked in the top 10 in all national polls. According to the 1950 brochure issued for the dedication, "The stadium is a living memorial to Wyoming's men and women who served their country in World War II." (WSA.)

The War Memorial Fieldhouse was completed on September 1, 1951, with the dedication held December 14 and 15. The total seating capacity was 11,000. The $20,000 removable basketball floor was raised 16 inches above the floor and consisted of 272 self-locking sections. The Cowboys played basketball in the field house until February 1982, when the Arena-Auditorium was completed. (UWPS.)

The University of Wyoming football team received national attention in 1969 for what has become known as the "Black 14." Coach Lloyd Eaton removed 14 African American players from the team because they wanted to wear black armbands in the October 18 game against Brigham Young University. The players wanted to protest BYU's policy that African Americans could not become priests in the Church of Jesus Christ of Latter-day Saints. The controversy led to a divided campus, with some students supporting the actions of the coach and others supporting the 14 players. Before the BYU game, some UW students protested (pictured) Eaton's actions. The undefeated Cowboys defeated BYU that day. (Irene Schubert Black 14 Collection, AHC.)

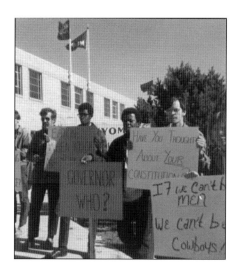

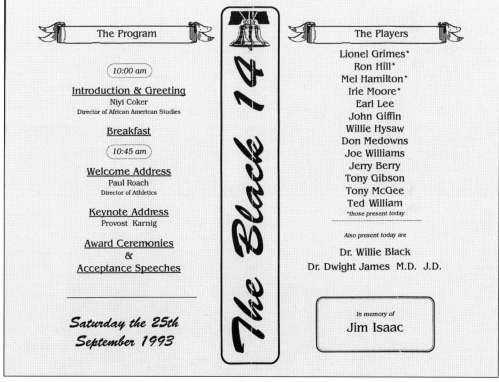

The Program	The Players
10:00 am	Lionel Grimes*
	Ron Hill*
Introduction & Greeting	Mel Hamilton*
Niyi Coker	Irie Moore*
Director of African American Studies	Earl Lee
	John Giffin
Breakfast	Willie Hysaw
	Don Medowns
10:45 am	Joe Williams
	Jerry Berry
Welcome Address	Tony Gibson
Paul Roach	Tony McGee
Director of Athletics	Ted William
	*those present today
Keynote Address	
Provost Karnig	Also present today are
	Dr. Willie Black
Award Ceremonies	Dr. Dwight James M.D. J.D.
&	
Acceptance Speeches	
	In memory of
Saturday the 25th	**Jim Isaac**
September 1993	

The Black 14

The *Branding Iron* reported that in September 1993 several of the Black 14 returned to UW to be "honored with the making of a documentary about their controversial protest." Adeniyi Coker, UW's director of African American Studies, produced the program about the players. Coker stated that with the documentary, "I intend to examine both sides and look at it 23 years later." This is the program published in the *Branding Iron* for the event that occurred on September 25, 1993. (*Branding Iron* Records, AHC.)

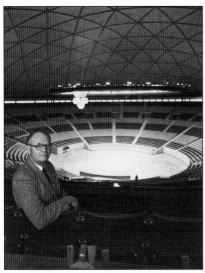

UW president Donald Veal sits in the new Arena-Auditorium after its completion in early 1982. The university dedicated the facility on the evening of Friday, February 19, 1982. Leo McCue, president of the UW Board of Trustees, and Gov. Ed Herschler spoke to the large crowd in attendance. Included in the audience were elected state officials and members of Wyoming's congressional delegation. After the dedication, the Denver Symphony Orchestra performed. The following day, fans enjoyed an open house and guided tours of the Arena-Auditorium, along with two basketball games: the Cowgirls defeated Air Force 81-60 in front of 13,000 fans, and later a full house of 15,004 fans enjoyed the Cowboys win over Air Force, 59-29. The dedication weekend ended on Sunday with a concert by the Charlie Daniels Band. (AHC Photo Collections.)

For many years, UW has had successful rodeo teams. The 1961 Cowboys rodeo team won the first national rodeo championship by winning the National Intercollegiate Rodeo Association tournament. All of the members were Wyoming natives. The team included, from left to right, (first row) Jim Moore and Jerry Kaufmann; (second row) Frank Shepperson, Leon Cook, Al Smith, and Fred Wilson. By 1993, the men's and women's rodeo teams were the most consistent UW teams at winning regional and national championships. The Cowboys team had captured regional championships in 7 of the previous 10 years, and the Cowgirls had captured 8 out of 10 regional championships—including three national championships—in the past four years. The rodeo teams continue their long history of success today. (AHC Photo Collections.)

Seven

YOUR UNIVERSITY STANDS STEADFAST IN WAR AND PEACE

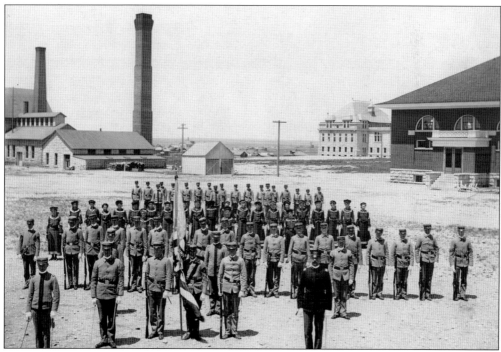

The requirements of the Morrill Act of 1862 (as amended by the act of 1890) included the teaching of military science. Every male student at UW was required to enroll in military drill. Military drills began as early as 1891, when the school established the School of Military Science and Tactics. The first uniforms were gray West Point fatigues. A Female Cadet Corps was organized after 1900. This c. 1904 photograph shows rows of male cadets with the female cadets between them. On the right side of the photograph is a portion of the building used as a gymnasium and armory. The university's male students had to take some type of military training until the fall semester of 1965, when the UW Board of Trustees made it optional at its February 1965 meeting. (A.C. Jones Papers, AHC.)

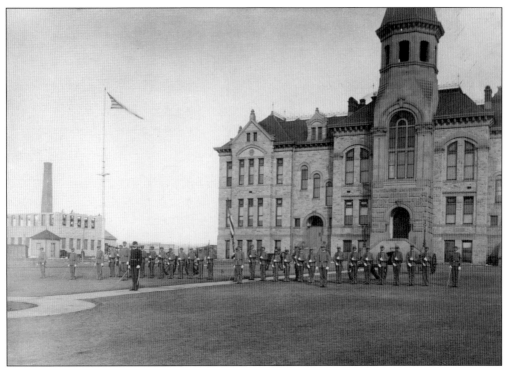

The Cadet Corps drilled in 1893 in front of Old Main with the partially completed Mechanical Arts Building on the left. The first Cadet Corps in 1891 had 55 members and was led by 1st Lt. D.I. Howell. 1st Lt. Edwin C. Bullock led the corps from 1892 to 1895; he also taught mathematics and astronomy. According to Wilson O. Clough in his book *A History of the University of Wyoming*, "Bullock was a strict disciplinarian, and organized a cadet court martial on military lines, with sentences which occasionally were lessened by the University authorities." Even so, he apparently was well liked by students. (A.C. Jones Papers, AHC.)

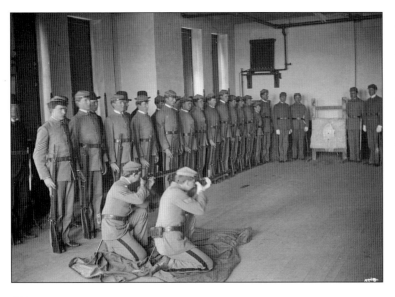

The Gymnasium and Armory Building opened in February 1904 with the armory in the basement, where these cadets held target practice. The building also contained a 45-foot-by-90-foot floor for military drills and athletic use and shower rooms for male and female students. (S.H. Knight Papers, AHC.)

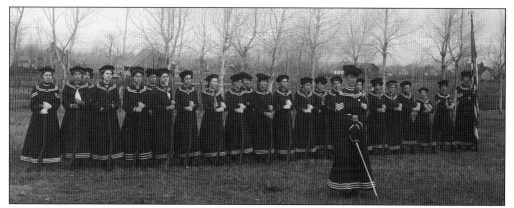

The Female Cadet Corps consisted of two companies of 30 students each. Capt. Belle Moore drilled the ladies shown in this 1902–1903 photograph. Women participated in training drills and received instruction in the manual of arms. The female cadets did exceptionally well, so the commandant of cadets combined the two female companies with the two male companies; the four companies drilled and marched in parades and reviews together. (A.C. Jones Papers, AHC.)

Here, the Cadet Corps participates in an artillery drill in 1910. Beginning in 1908, Lt. Harol D. Coburn, a former cadet captain, led the corps. After Coburn transferred to another post in 1911, a retired officer, 1st Lt. Beverly C. Daly, took command. A retired officer was assigned because the university was not able to maintain the needed enrollment of 100 cadets for an active officer. (B.C. Buffum Papers, AHC.)

The Students' Army Training Corps (SATC) exercises near the Gymnasium and Armory Building on February 25, 1919. World War I brought many changes to campus. Various buildings and grounds were used for military training, the athletic field was used as a parade ground, and the gymnasium became a barracks. With the assistance of federal funding, a mess hall, which became known as the Commons, was constructed on the north side of the campus. Its original purpose was to feed the members of the SATC; it was used as a student cafeteria after the war. (S.H. Knight Papers, AHC.)

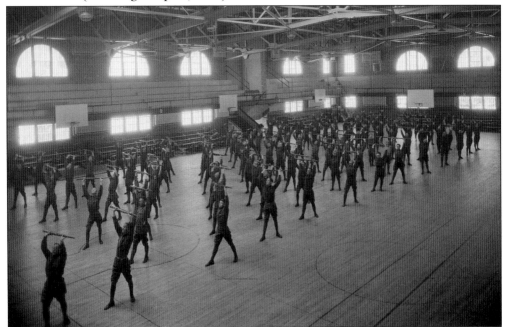

Members of the Reserve Officers Training Corps (ROTC) exercise in Half Acre Gym in this February 1926 image. The National Defense Act of 1916 created the ROTC. UW was one of the first universities to apply for an ROTC unit. (Ludwig-Svenson Studio Collection, AHC.)

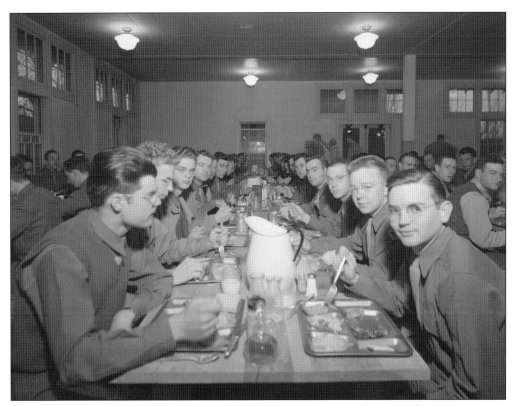

Members of the Army Specialized Training Program (ASTP) enjoy a dinner in the UW Commons in 1944. Members of the ASTP began arriving on campus in June 1943, and the formal instruction program began on July 12. UW served as a training center for basic phase students and for advanced engineers. The Engineering Building served as the center for training. During 1943, UW hosted 1,025 men in the Army and 100 Navy Air Corps trainees. UW president J. Lewis Morrill said the "university shall serve the nation in a most vital role both during the war and afterward. That the university is able to carry on such an extensive program should be a point of pride with all alumni." (Ludwig-Svenson Studio Collection, AHC.)

The ASTP band practices in McWhinnie Hall in 1945. Members of the ASTP resided on campus for one or two 12-week periods. By mid-1943, more than 1,000 UW students served in the military: 902 in the Army, 481 in the Army Air Corps, 174 in the Navy, 60 in the Navy Air Corps, 53 in the Marines, and five in the Coast Guard. Also, 25 female students served in the WAACS, WAVES, SPARS, and women's reserve of the Marines. (Ludwig-Svenson Studio Collection, AHC.)

On October 7, 1966, the *Branding Iron* reported that the UW Alumni Association would donate to the university a bronze memorial plaque honoring alums killed in the Vietnam War. On October 21, 1967, the plaque was dedicated as part of homecoming activities. The memorial included the names of the five alums who died in Vietnam: Craig S. Blackner, Lyman; Phillip O. Robinson, Sheridan; Joseph B. Fearno, Mena, Arkansas; Gilbert B. Bush, Laramie; and William B. Esslinger, Cheyenne. The native sandstone memorial reads: "In tribute to the alumni of the University of Wyoming who have given so much for so many in the distant fields of Viet Nam. If they should die, think not of death, but rather that they have died that freedom may prevail. Youth foregone, dreams unseen, god give them joy in knowing what freedom their death has brought." (UWPS.)

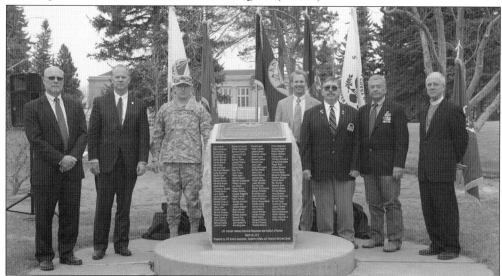

On March 30, 2012, UW's Vietnam memorial was rededicated as part of the second-annual Wyoming Veterans Welcome Home Day. The date was selected because March 30, 1973, was the day the last combat troops left Vietnam. Those who spoke at the ceremony are, from left to right, UW president Tom Buchanan; Gov. Matt Mead; Maj. Gen. Luke Reiner; UW provost Myron Allen; Barry Gasdek, who received Distinguished Service Cross for his service during the war; Lee Alley, also a recipient of the Distinguished Service Cross and author of *Back from War*; and the Venerable Richard Naumann. (UWPS.)

Eight

WYOMING'S UNIVERSITY

A comparison of this 1962 aerial photograph of campus to an earlier aerial view (on page 52) reveals the Quadra Dangle/Gray's Gable visible in the upper left corner of both images, which helps demonstrate how the university has expanded eastward in 76 years. Buildings west of the stadium and field house are the former married student residences, which were removed to make way for the Bison Run Village Apartments. Compare this to a later aerial view (on page 125) to see how the campus grew during the next 50 years. The Quadra Dangle, which faces the golf course, is no longer the lone building on the prairie. (UWPS.)

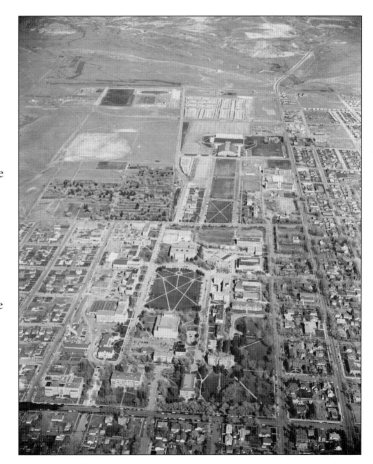

Construction of the Nellie Tayloe Ross Hall began in 1960. It replaced the older Hoyt Hall as a dormitory for female students. Named for Wyoming's only, and the country's first, female governor, Ross Hall was part of a major building program undertaken following the end of World War II. Six buildings were dedicated as part of the 72d commencement. The dormitory was opened for summer school in June 1961. According to a *Branding Iron* story in May 1961, "Rooms in the new dorm feature telephones, matching draperies and bedspreads, and blankets imprinted with the University seal." Other conveniences included "individual mail boxes, built-in ironing facilities, storage rooms, a date room, and a redwood sun deck on the roof." (Nellie Tayloe Ross Papers, AHC.)

The Ross Hall lobby is a familiar place to many on the UW campus. Pictured here when it was newly opened, the lobby area served as a faculty/staff cafeteria for many years and is now known as the Ross Hall Café. One can enjoy the view across Prexy's Pasture while seated in front of the large north windows. (AHC Photo Collections.)

The Octopus Tree, first planted along with about 20 other trees, was accidentally created when the groundskeeper continually mowed over it, causing it to grow into the odd shape from which it takes its name. This tree was labeled a hazard in the 1980s and removed. The legend of the Octopus Tree, recalled in the October 8, 2010, issue of the *Branding Iron*, states that "anyone who has not been kissed under it is still a freshman at the university, regardless of the number of credit hours the student has obtained." A new tree was planted in 2010, and a ceremony marked the revival of the tradition. The new tree is located south of the Williams Conservatory. (WSA.)

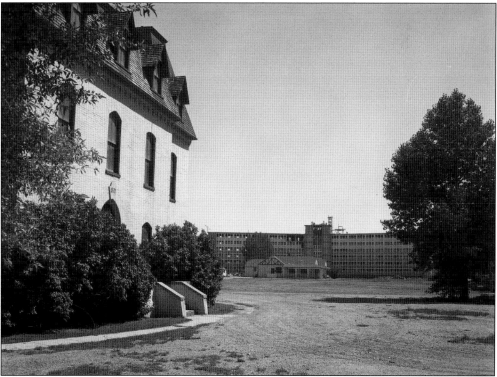

Talbot Hall (left foreground) was built in 1878 and, after acquisition by the university, served as a dormitory and dining quarters for athletic teams. The stucco building in the center of the photograph is Dray Cottage. Constructed around 1924, this building met a variety of housing needs until it was razed to make way for the modern residence halls. In the background is Hill Hall, which is under construction. The Crane-Hill Complex opened in 1963. There was some concern when it was announced that due to higher enrollment numbers of female students, Hill Hall would be a coed dormitory. (UWPS.)

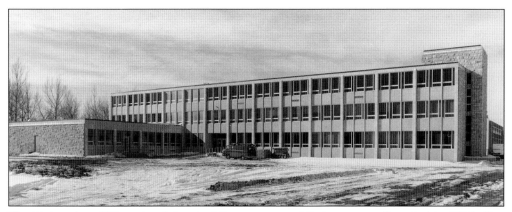

The University of Wyoming School of Commerce and Industry was founded in 1899. The photograph above shows the original building during construction in 1960. The image below is of the former C&I Building (now the College of Business), which was renovated and expanded in 2009 and 2010 with a design by Kallmann McKinnell & Wood Architects. In October 2011, the building received gold certification from LEED (Leadership in Energy and Environmental Design). The renovations and additions allowed the college to unite the divisions that were located in different buildings across campus. The new space provides a commodities-trading room, behavioral and multimedia laboratories, an executive boardroom, conference and seminar rooms, and a large auditorium. The centerpiece of the building is the Jonah Bank Atrium, which serves as a gathering space and has a stock ticker. (Above, AHC Photo Collections; below, UWPS.)

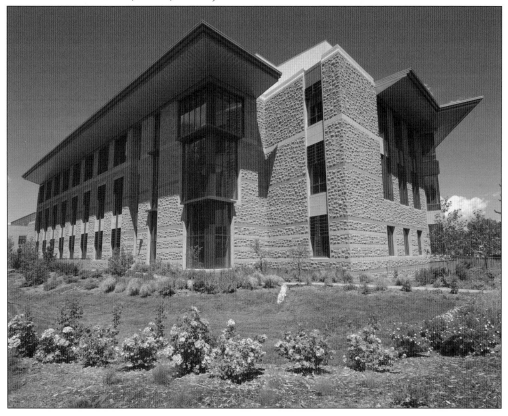

One of the largest construction projects on campus was the George Duke Humphrey Science Center. In 1965, many conversations addressed the question of where to locate the new Science Center. Two years earlier, when planning for the complex was just beginning, it was believed that the best location for it would be on the north end of the old Corbett Field and east of the Wyoming Union. Further consideration revealed that the most advantageous spot would be on the western side of campus close to existing science-related facilities. (AHC Photo Collections.)

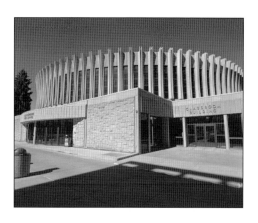

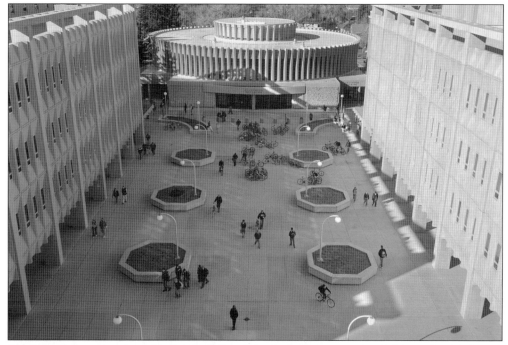

The decision was to place the first building (physical science, on the right) on the northwest corner of Prexy's Pasture and the second building (biological science, on the left) on the southwest corner. Following that announcement, comments poured in from around the state opposing the idea of placing buildings on Prexy's Pasture. At the June 1965 board meeting, the trustees decided to place the new facilities west of the Arts & Sciences Building. The George Duke Humphrey Science Center includes the Classroom Building as well as the Physical and Biological Science Buildings. In order to proceed with construction of the Science Center, two existing buildings had to be demolished: the Graduate (Normal) School Building and the Art/Post Office Building. This 2007 photograph shows the three buildings, along with the mall that covers the underground portion of the complex. (UW Photo Database.)

William Robertson Coe, benefactor to the university, purchased Buffalo Bill Cody's Irma Lake Lodge Ranch near Cody, Wyoming, and it was there that he developed a close friendship with Milward Simpson. Coe, deeply interested in the American West, built his own collection of Western Americana, which was donated to Yale University, but Coe's generosity impacted the University of Wyoming as well, and he received an honorary degree from UW in 1948. The first of his gifts was a collection of 700 items of Western Americana that was donated to the UW Library. By the 1950s, the library was once again inadequate for the needs of the campus population, and plans were drawn up for a new one. In 1954, Coe donated $750,000 to be used in establishing a comprehensive American Studies Program. Coe passed away on March 15, 1955. He bequeathed $1.2 million to UW to build a new facility to house both the library and the newly created American Studies Program, which ranks among the earliest such programs in the United States. (AHC Photo Collections.)

The growth of the university can be measured in small part by the growth of the library. By the late 1970s, it was necessary to add on to Coe Library. The new wing, completed in 1978, was to be used primarily as a stack tower, though some offices and service points were relocated to the new space. This is the excavation for the addition. (AHC Photo Collections.)

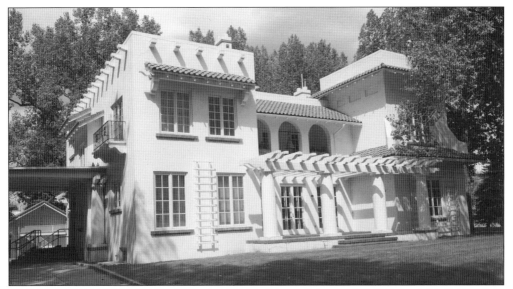

The Cooper Mansion is home to the University of Wyoming American Studies Program. In 1980, the university purchased the property with the intention of demolishing the house to provide parking space. Following a successful campaign launched by a local group called Friends of the Cooper Mansion, the building was stabilized and eventually turned into offices and classroom space. Designed by Laramie architect Wilbur Hitchcock, it is significant in Wyoming due to the blending of Mission and Pueblo styles of architecture. It was listed in the National Register of Historic Places on August 8, 1983. (UWPS.)

In 2009, faculty, staff, and students began relocating offices into the expanded Coe Library. This addition redirected the main entrance of the library from the old entrance on 13th Street to a north entrance convenient to the Wyoming Union; it impacted the entire organizational structure of the libraries. The Science Library, once housed in the underground portion of the Science Complex, was merged with the main library collection, and the former Science Library became the Library Annex, housing the back catalog of periodicals and the US Documents Collection. The Grace Raymond Hebard Collection, the most comprehensive collection of published materials about Wyoming, was returned to Coe Library after being housed in the American Heritage Center for over a decade. (UWPS.)

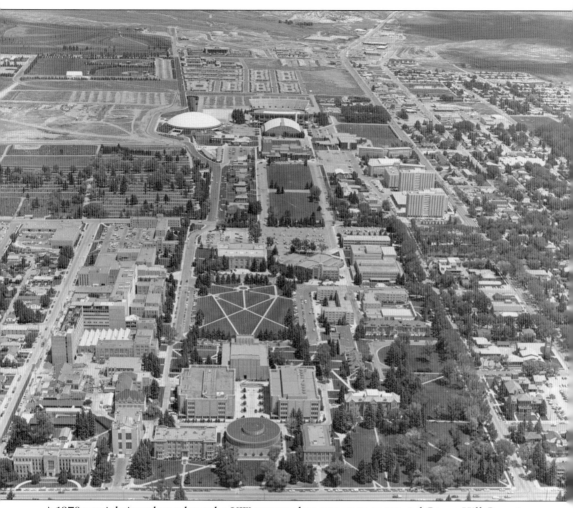

A 1970s aerial view shows how the UW campus has grown to surround Green Hill Cemetery. The building program that expanded the campus in the 1960s is evident with the addition of the new Science Complex on the western edge (center foreground) of the campus, along with the Pharmacy Building. In the area where Veteran's Village stood in the 1940s and 1950s (upper right), there are now coed dorms. Until 1972, the 12-story McIntyre Dormitory was the tallest building in the state of Wyoming—just a foot taller than its companion, White Hall. Gone are the Peanut Pond, bookstore, and the Music Building. (AHC Photo Collections.)

The Centennial Complex, completed in 1993, houses the American Heritage Center (AHC) and the UW Art Museum. Its name resulted from the first major university fundraising campaign started in 1986 that was tied to the school's centennial celebration. Established in 1945, the AHC is now an internationally known manuscript repository, holding more than 3,000 collections related to the history of Wyoming, the West, and select national topics. It also serves as the university's archives and maintains UW's collection of rare books in the Toppan Rare Books Library. The UW Art Museum opened in 1972 in the lower level of the Fine Arts Building. Since 1976, the museum has been accredited by the American Association of Museums; it hosts an average of 16 exhibitions per year and houses a collection of nearly 8,000 art objects. Internationally acclaimed architect Antoine Predock designed the building. (UW Photo Database.)

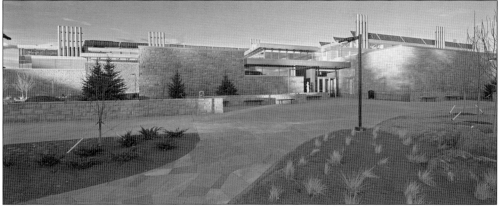

Replacing some of the outdated art instruction facilities located in the old Wainwright Bungalows and remainders of the old dilapidated married student housing facilities north of the Fine Arts Building, the Visual Arts Building opened to rave reviews in January 2012. Located east of the Centennial Complex, the facility provides space for administrative offices, a large student commons area, a gallery for exhibiting students' creations, and a large lecture room for art classes. The building also has room for faculty offices and individual studio space. (UW Photo Database.)

The Dick and Lynn Cheney Plaza is located on the southwest corner of Prexy's Pasture directly in front of the Cheney International Center. At the dedication, UW president Tom Buchanan spoke of the Cheney's endowment: "Through their generous gift, we now have a beautiful facility to house all of our international programs. Equally as important, if not more so, the Cheneys have funded a scholarship endowment to support study abroad opportunities for UW Students. Because of the Cheneys, we have sent students all over the world." This is the second plaza honoring a Wyoming political family. (UWPS.)

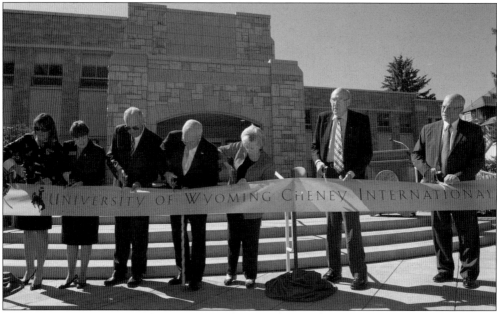

Former vice president Dick Cheney (center) and his wife, Lynne (third from right), cut the ribbon to open the UW Cheney International Center in September 2009. Former US senator Alan Simpson (second from right) also participated in the event. The Cheney International Center is the home of all UW's international offices. Dick is one of the most noted UW alums. Born and raised in Nebraska and later living in Casper, Wyoming, he received BA and MA degrees in political science from UW in the 1960s. In his public-service career, Cheney held various positions in the Nixon administration and served as chief of staff for Pres. Gerald Ford. In 1978, Wyoming elected him to the US House of Representatives. He served in that capacity until Pres. George H.W. Bush appointed him secretary of defense in 1989. Cheney then served as vice president to Pres. George W. Bush from 2001 to 2009. Lynne was born and raised in Casper. She received a BA in English literature from Colorado College, an MA from the University of Colorado at Boulder, and a PhD from the University of Wisconsin at Madison. She served as chair of the National Endowment for the Humanities from 1986 to 1993. (UWPS.)

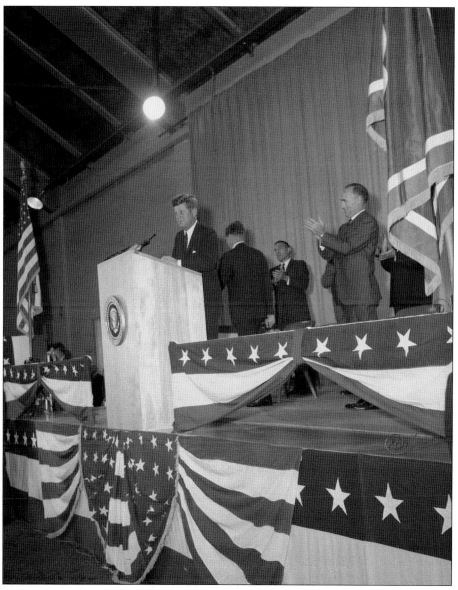

Pres. John F. Kennedy visited UW on September 25, 1963, during his tour of the West. The president arrived at Brees Field slightly after noon that day and was met by Wyoming senator Gale McGee, a former history professor at UW; Gov. Cliff Hansen; and UW president George Humphrey. Thousands of residents and students lined Laramie's streets to get a glimpse of Kennedy. After a quick tour of the campus, the parade ended at the War Memorial Fieldhouse. Humphrey introduced Governor Hansen, who then introduced President Kennedy to the audience of 13,000; another 5,000 stood outside the field house. The president spoke for 45 minutes, and part of his speech was about the need for education: "Knowledge is power as never before. The future of the world depends in the final analysis upon the United States and upon or willingness to reach those decisions on complicated matters which face us with courage and clarity." In *Those Good Years at Wyoming U*, Kathy Karpan's article "President Kennedy Comes to Laramie" recorded Governor Hansen's observation, "If one word might describe the average reaction, it was that here, indeed, was Greatness." (UWPS.)

The Department of Anthropology moved into the former Law School Building in the 1970s. Dr. William Mulloy joined the faculty of the Department of Anthropology, Sociology, and Economics in 1948. In 1968, he established the Wyoming Anthropological Museum, serving as curator until his death in 1978. Renowned for his work in North American Plains archaeology, he is best known for his research on Easter Island. In 1966, George C. Frison became head of the newly formed Department of Anthropology, a position he held until 1987. Under his direction, the department has attracted internationally recognized researchers, lecturers, and visiting speakers. The Frison Institute and the Anthropology Museum are housed in the new building seen here. Related agencies housed here include the Office of the Wyoming State Archaeologist and the State Historic Preservation Office. (UWPS.)

The Information Technology Center (ITC) was completed in December 2008. It is home to the UW Division of Information Technology. The center is designed to meet the computing and data needs of UW students, faculty, and staff. (UWPS.)

Opened in 1994, The Louis O. and Terua P. Williams Conservatory is a working facility used by the Department of Botany, along with other university departments. Named for the Williamses, whose generous donations made the building possible, it also serves as a "serene getaway for students and members of the community." Botany staff members assist those seeking advice about plants. (UWPS.)

The Simpson Family Plaza is located on the southeast corner of Prexy's Pasture just outside the Wyoming Student Union. Members of the Simpson family and the University of Wyoming have a long history. Gov. Milward Simpson, a UW alum, served as president of the UW Board of Trustees for 12 of the 16 years he was on the board. His sons Peter and Alan served in the state legislature, and Alan went on to serve as a US senator. Peter retired from the UW faculty after holding a variety of positions, including political science professor, where one of his most popular courses was "Wyoming's Political Identity." The plaza received the 2007 Honor Award for Design from the American Society of Landscape Architects Colorado Chapter. (UWPS.)

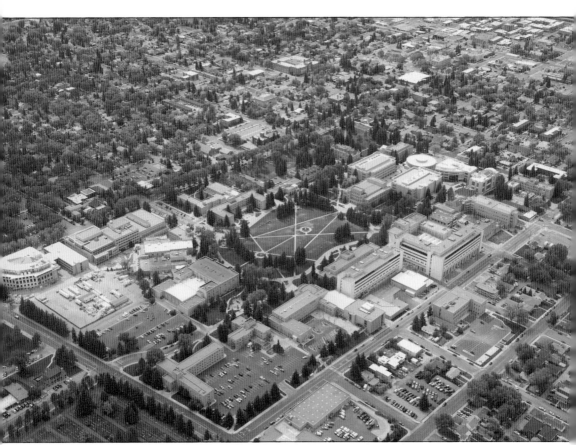

Shown here and on the facing page are two aerial images from slightly different angles. This image, taken in 2009, illustrates the several of the expansion/renovation projects on campus. Of particular note are the additions to the College of Business, Coe Library, and the Wyoming Union. Also note the changes to Prexy's Pasture; the asphalt roadway was replaced with meandering walkways and naturalistic plantings. On the western end of campus (lower left), the Earth Science addition to the Geology Building is visible. (UW Photo Database.)

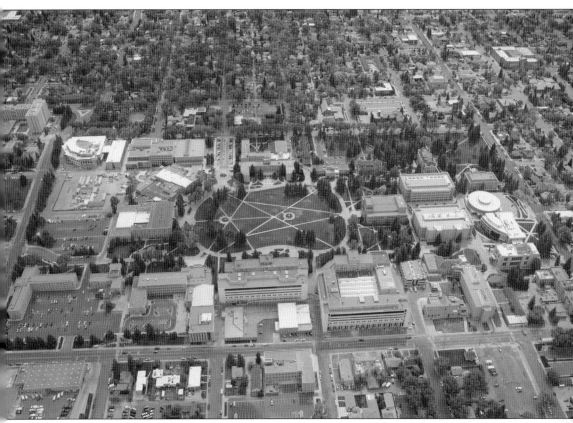

As university programs expanded and the student population rose, another building program increased the size of the main campus. In this c. 2011 aerial view, several additions to existing buildings are apparent, along with new buildings. On the south side of campus, additions to the College of Business (upper left) Building and William Robertson Coe Library are visible. The new Anthropology Building is north of the Agriculture Building in the foreground. Demolition of the "Cowboy Dorm" and the old power plant has not yet begun. Additions to the original Science Hall (lower right) swamp the original structure. (UW Photo Database.)

The Robert and Carol Berry Biodiversity Conservation Center is located just west of the Earth Sciences/Geology Building. Opened in January 2011, the center houses the Vertebrate Collection, which was in storage for over 30 years and is now accessible. It includes more than 6,300 mammals, 2,500 birds, and about 3,000 fish, reptiles, and amphibians that were collected for research beginning in the late 1870s. Teaching specimens can be viewed in the second floor display cases and the first floor lobby. According to the UW News Service, the mission of the center is "to document and understand regional and global biological diversity through the acquisition and investigation of collections made by faculty, staff, and students to advance academic knowledge and public appreciation of the natural world." (UW Photo Database.)

The Bim Kendall House (formerly the Verna J. Hitchcock House) at Eighth and Fremont Streets is home to the Environment and Natural Resources Program (ENR), including the Helga Otto Haub School, William D. Ruckelshaus Institute of Environment and Natural Resources, and the Wyoming Conservation Corps. A classroom, offices, and common spaces for students, faculty, and staff are inside this historic building, which was renovated and expanded to meet "green building" standards. The Bergman Gardens, a xeriscape, includes a variety of native plants honoring former ENR director Harold Bergman. (UWPS.)

Elements of the original Wyoming Union are apparent in this photograph taken from the east side of the renovated and expanded facility. Interior spaces were remodeled, eliminating the old beer garden and bowling alley, much to the dismay of former students and staff. Billiards is still available in the basement. Most of the food service was relocated from the lower level to the main level, and the cafeteria was eliminated. (UWPS.)

The Curtis and Marian Rochelle Athletics Center opened on August 31, 2001, and serves the academic and athletic needs of all 17 UW intercollegiate sports. The facility includes an academic and counseling center, a sports medicine facility, a locker room for the football team, and a strength and conditioning area. It is also home to the UW Athletics Hall of Fame, which chronicles "the great men and women who have built the legacy of Cowboy and Cowgirl athletics." This facility was entirely paid for by private donations. (UW Photo Database.)

The ground-breaking ceremony for the new Energy Innovation Center took place on November 19, 2010. According to a UW marketing brochure, it will be the home of the School of Energy Resources, established in 2006 to "bolster the university's energy-related education, research, and outreach." The 30,000-square-foot, state-of-the-art facility houses laboratories designed specifically for energy research, computational modeling, and distance collaboration. Classrooms are equipped to provide real-world tools and experiences and a state-of-the-art drilling simulation lab. The building is scheduled to open in 2012. (UW Photo Database.)

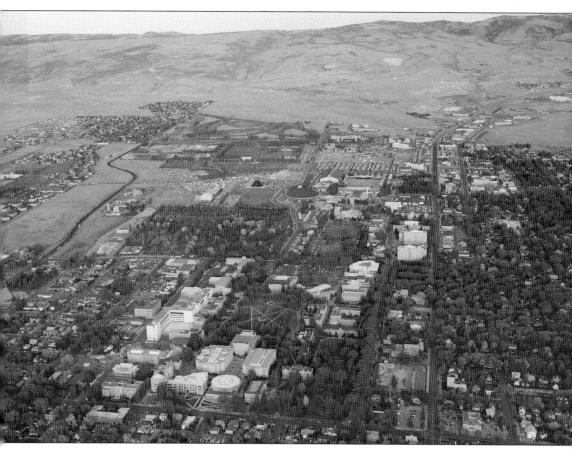

This photograph was taken during the UW/University of Nebraska football game played on September 24, 2011. The Cowboys had not played the Cornhuskers since 1994, when they lost a close game in Lincoln, 42-32. Nebraska was ranked ninth in the country when the Cowboys played them in 2011, and the Cornhuskers won the game 38-14. This image shows many of the changes to buildings on campus. The Berry Biodiversity Conservation Center is just west of the Earth Science Building. North of the Classroom Building is the original Agriculture Building, which was renovated and expanded to become the Health Sciences Building. On the east end of campus, the new Visual Arts Building is under construction east of the Centennial Complex. (UW Photo Database.)

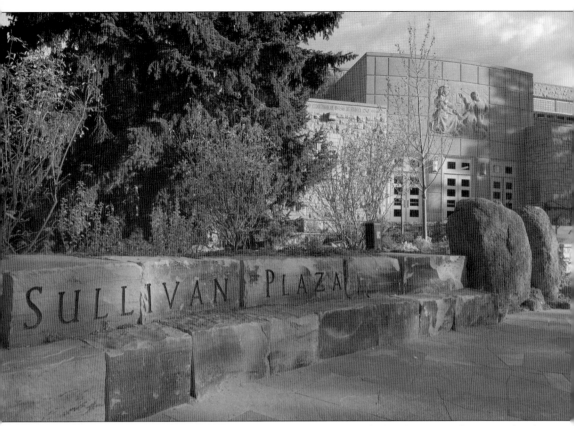

Plazas anchoring the corners of Prexy's Pasture are part of a landscaping plan to make the campus more visually appealing. The third such plaza honors former governor Mike Sullivan and his wife, Jane. Dedicated on October 5, 2012, it is located at the northeast corner of the pasture near the College of Education. A university press release dated October 3, 2012, notes that the plaza "incorporates natural stone and ironwork benches, Vedauwoo-style granite boulder and native plant landscaping, and evergreen and aspen trees. It creates a place for students and visitors to relax, and is a byway for pedestrians and bicyclists. Finally, it will enhance the entrance to the UW College of Education." (Photograph by Rick Walters, AHC Photo Collections.)

BIBLIOGRAPHY

Branding Iron. Laramie, WY: Associated Students of the University of Wyoming, 1923–.

Breithaupt, Brent H., "Dinosaurs to Gold Ores: The 100 Year History of the University of Wyoming Geological Museum," *Fiftieth Anniversary Field Conference, Wyoming Geological Association Guidebook*.

Catalogue for the Year . . . And Announcement for the Year. Laramie, WY: Republican Book and Job Print, 1891–1963.

Clough, Wilson O. *A History of the University of Wyoming, 1887–1964*. Revised and corrected, with index. Laramie, WY: University of Wyoming, 1965.

Crane, Arthur G. *The University of Wyoming 1940: A Pioneer Comes of Age*. Laramie, WY: University of Wyoming, May 1940.

Diggs, D. Teddy, "Education for Head or Hand? Land Grant Universities of Utah and Wyoming," *Annals of Wyoming*, vol. 58 (Fall 1986): p. 30–45.

The Fossil Fields of Wyoming, Reports by Members of the Union Pacific Expedition. Omaha, NE: Union Pacific Railroad Company, 1909.

Hardy, Deborah. *Wyoming University, the First 100 Years, 1886–1986*. Laramie, WY: University of Wyoming, 1986.

Karpan, Kathy. "President Kennedy Comes to Laramie," *Those Good Years at Wyoming U.* ed. by R.E. McWhinnie. Laramie, WY: The University of Wyoming, 1965, p. 312–315.

Knight, Wilbur C. "The Wyoming Fossil Fields Expedition of July 1899," *National Geographic*, vol. 11, no. 12 (December 1900): p. 449–465.

Marmor, Jason D. *Historic American Buildings Survey, The University of Wyoming Campus*. Denver, CO: Historic American Buildings Survey, National Park Service, US Department of the Interior, 1994.

Mayer, Jennifer. *William Robertson Coe Library: Reflections on the Past*. Laramie, WY: University of Wyoming Libraries, 2008.

Murphy, Victoria. *Wyoming, A 20th Century History of Its Citizens, Businesses and Institutions*. Carlsbad, CA: Heritage Media Corp., 1999.

Needed—A Wyoming Union Addition. Laramie, WY: University of Wyoming, 1956–1957.

Reckling, Frederick W. and JoAnn B. *Samuel Howell "Doc" Knight, Mr. Wyoming University*. Laramie, WY: University of Wyoming Alumni Association, 1998.

Residence Halls for Women. Laramie, WY: University of Wyoming, 1941.

Session Laws of Wyoming Territory, Passed by the Ninth Legislative Assembly, Convened at Cheyenne, on the Twelfth Day of January, 1886, p. 84. Cheyenne, WY: Vaughn & Montgomery, Printers and Binders, Democratic Leader Office, 1886.

Some of Wyoming's Vertebrate Fossils. Omaha, NE: Union Pacific R.R. Co., 1899.

Souvenir . . . Annual Commencement of the University of Wyoming. Laramie, WY: University of Wyoming, 1891.

The University Melange. Laramie, WY: University of Wyoming, 1904–1913.

University of Wyoming Bulletin. Laramie, WY: University of Wyoming, 1913–1970.

University of Wyoming Land-Grant College Radio Hour. Laramie, WY: University of Wyoming, September 28, 1938.

Walch, Timothy, ed. *Uncommon Americans: The Lives and Legacies of Herbert and Lou Henry Hoover*. Westport, CT: Praeger, 2003.

The Wyoming Student. Laramie, WY: Students of the University of Wyoming, 1898–1923.

"Wyoming U. on the Air from Auditorium Wednesday," *Branding Iron*, vol. 44, no. 1 (September 22, 1938): p. 6.

DISCOVER THOUSANDS OF LOCAL HISTORY BOOKS
FEATURING MILLIONS OF VINTAGE IMAGES

Arcadia Publishing, the leading local history publisher in the United States, is committed to making history accessible and meaningful through publishing books that celebrate and preserve the heritage of America's people and places.

Find more books like this at
www.arcadiapublishing.com

Search for your hometown history, your old stomping grounds, and even your favorite sports team.

Consistent with our mission to preserve history on a local level, this book was printed in South Carolina on American-made paper and manufactured entirely in the United States. Products carrying the accredited Forest Stewardship Council (FSC) label are printed on 100 percent FSC-certified paper.

MADE IN THE USA